The Hopi Approach to the Art of

KACHINA DOLL CARVING

Erik Bromberg

Introduction by
Dr. Frederick Dockstader

Drawings by
Neil David, Sr.

Schiffer Publishing Ltd

West Chester, Pennsylvania 19380

ACKNOWLEDGMENTS

My thanks to Michael Mouchette for his professional job of photography. At age 43 his work has appeared in most major U.S. magazines. Before becoming attached to the University of New Mexico, he free-lanced for years in New York city and Los Angeles,

to Von Monongye at present the premier Kachina doll carver in Hopi. Von took time off from running his fine gallery in Hopi to clarify many obscure points for me,

to Natalie Rose and Vonette Rae Monongye who kindly lent their Kachina dolls for our back cover,

to Bruce McGee who has worked since childhood for the McGee Corporation which owns the Keams Canyon Trading Post and subsidiaries at Polacca and Pinon, Arizona. His advice to me comes from an encyclopediac knowledge of Hopi crafts,

and of course to Fred Dockstader and Barton Wright who between them know almost everything about Kachinas and Kachina dolls.

DEDICATION

To the young artists of Hopi.

Front cover: Poli Mana by Oren Poley Jr.
Back cover: Pahlik Mana and Hemis Mana by Von Monongye.

Photographs by Michael Mouchette

Drawings by Neil David

Copyright 1986 © by Erik Bromberg.
Library of Congress Catalog Number: 86-70331.

Printed in the United States of America.
ISBN: 0-88740-062-0
Published by Schiffer Publishing Ltd.
1469 Morstein Road
West Chester, Pennsylvania 19380

This book may be purchased from the publisher.
Please include $1.50 postage.
Try your bookstore first.

Preface

The approach to this essay is not that of an academic, but rather it reflects the experiences of a trader among the Hopi. While Kachina dolls can be made by all Pueblo tribes, only rarely are dolls made for sale except by the Hopi. There are a few Zuni, Jemez, and San Juan Kachina dolls available which, while authentic, are only a negligible percentage of dolls on the market today.

The Kachina doll discussed herein is a carved representation of a ceremonial figure taking part in celebration of the Kachina religion. They are carved, according to Wright, as an effort by the male dancers to pass on to the women some contact with the supernatural which the men have experienced.[1]

J.W. Fewkes called them "kindergarten instruction materials of the Hopi." (In a letter to me, Barton Wright says, "The doll is not an instructional gift to a girl. It is a prayer object, a religious item that has meaning only in those cultures that practice Pueblo religion.") Each figure is masked. Unmasked figures are not Kachina dolls, rather they are social dancer dolls. For purposes of easier discussion, both types will be designated as Kachina dolls in this essay. For discussion of the Kachina religion and ceremonies, see books listed in the attached bibliography.

Dockstader has a good antidote for those who would enter the study of Kachinas expecting all things somber. Says he, "The pure fun-making aspect of the (Kachina) cult should not be minimized. A people who are prone to laughter as the Hopis would never flourish under a fearsome, doleful Calvinist religion. Therefore the Kachinas who enact the roles of fun-makers and clowns, playing tricks, acting out absurd pantomines, or cleverly mimicking spectators, have as important a function in Kachina religious activity as joy and laughter do in Hopi daily life. Further, the burlesque drama and impersonations are opportunities to strike back at Hopi oppressors, for example, the white man. This affords a psychological release that is important for a people such as the Hopis who have a strong inclination for peaceful living and whose nature is not to advocate armed revolt unless the oppressive forces become as intolerable as at the time of the 1680 Revolt."[2]

The reader must not fall into the common trap of regarding the mask and costume of all Kachinas as fixed. Discussing the Poli Taka (Butterfly Man), Barton Wright relates that a single Hopi dancer had a dream and as a result, the Poli Taka costume for one dance was radically changed. He also relates how the extinct Quail Kachina was revived due to a dream by another Hopi. A Hopi friend tells me how he danced the Ahote with a neighbor who envisioned a changed mask and made it for a dance. A recent dance presented the Sipikne (Zuni Warrior) in a dozen or so costume and mask variations. A common event is the variation in attire of a Kachina from village to village. When I puzzled over the appearance of an Albino Chakwaina, a Hopi friend remarked succinctly: "All races have albinos. Why can't the Hopi have them?" If the logic of this statement baffles you, please remember that you are not a Hopi!

iv

"Because the Hopis have no writing, their religion and their mythologies are carried in their minds. These are passed from generation to generation by word of mouth. Sculpture and painting helped them preserve these ideologies. The Hopi Kachina dolls are as much a Bible in wood as the great Gothic cathedrals were Bibles in stone. They are also a visual aid in the form of sculpture. But they also fill the need, or the unconscious will-to-form, of the artist; and by the same token, Kachina dolls satisfy the observer's need to interpret plastic form and enjoy an emotional reaction from the experience. The emotional experience of the artist and the observer is undoubtedly a basic human characteristic, and is responsible for the fact that no culture or civilization regardless of its rank, is without an art".

Robert Bruce Spaulding "Hopi Kachina Sculpture" MA Thesis (Art), University of Denver, 1953, p. 34.

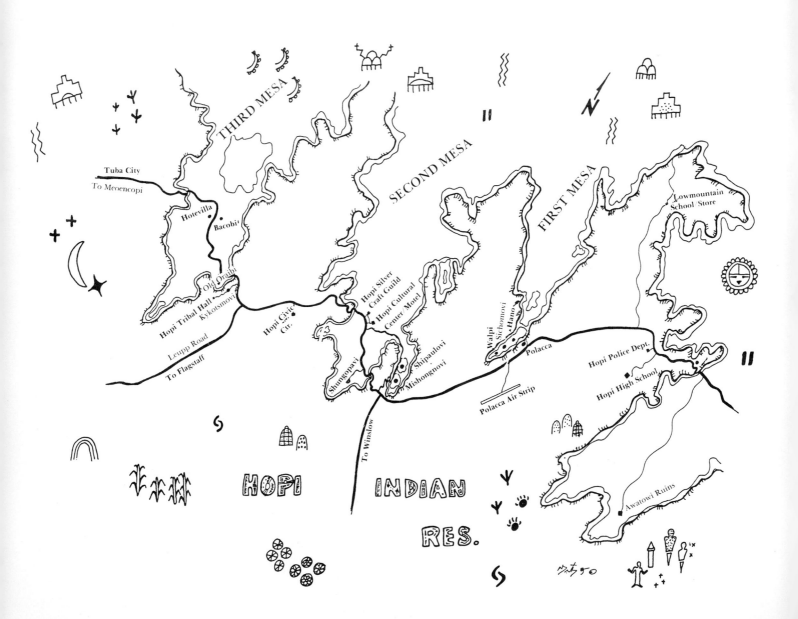

Contents

Introduction

The Hopi, in common with the other Pueblo peoples, have developed a unique religious form in the *Kachina*. Personified by masked performers who replicate supernatural Beings regarded as messengers for human prayers, the members of the Hopi Kachina Society follow an age-old dance form, providing individual roles in keeping with the traditional dictates of the particular Kachina which they represent. This is not only a religious belief, but one which also encompasses great creative qualities of choreography, mask design, costuming, and feather artistry. To my mind, there is no other esthetic dance form in America which equals the effect of a line of 50 or more dancers, all similarly costumed, providing a day-long pageant of color, music, rhythm and grace.

It is a fascinating world, for it duplicates in almost every way the day-to-day life of the Hopi people themselves. Just as there are whole families — uncles, aunts, sisters, brothers, grandfathers and grandmothers — there are also wives and sweethearts, lovers and flirts; naughty boys as well as stern disciplinarians. And they parallel almost every occupation and facet of life, including the birds, animals and plants and other natural phenomena which surounds the Hopi world. It is this parallelism which makes so much of the Hopi religious life an absorbing drama; no other tribe, to my knowledge, has so completely replicated every-day life in its own religious observance.

As knowledge of this art form slowly grew beyond the Pueblo people and their neighbors, what was earlier the small world of the Kachina people has exploded into a greatly enlarged sphere. Where once the Kachina had the responsibility only of the relatively constricted Southwest, now the interest in this beautiful religious phenomenon covers the planet. The Hopi, of course, have long recognized this universality, but it has taken the non-Hopi community a long time to realize the extent of the benevolence of these beautiful spirits. The impact of this dynamic esthetic upon the non-Hopi art community has also grown remarkably; and today almost all serious enthusiasts are familiar with the form, if not the detail, of the Hopi Kachina. There no longer remains any question as to the verity of the Kachina doll; it has discarded its old-time image as a curio — in its own right it has become a highly sought after (and highly priced) sculptural art form.

The total number of masked Kachinas in the Hopi pantheon is estimated at numbers ranging from 250 to 500 — depending entirely upon which "authority" one reads. No one really knows, due almost entirely to the evanescent nature of the religious observance. Any member of the Kachina Society can introduce a completely different mask design, and have it adopted as wholly legitimate. Once it is introduced, it becomes for all purposes a quite acceptable part of Hopi religious life, and will then be incorporated into the ceremonial

calendar as the occasion warrants; this is largely up to the sponsor of the dance, or the introducer. And if there is no demand for the appearance of the particular Being, it may well languish for years, or decades — or disappear altogether. And from December until May or June, the open season will offer an opportunity for these masked personages to perform for the benefit of all of the people.

It is a truism that Kachinas have come and gone over the centuries as man has welcomed them into today's world; as many have flourished, others have been ignored and allowed to pass into a temporary or permanent oblivion. Most knowledgeable devotees know that new Kachinas may appear from time to time, for various reasons; if nurtured, these will develop, prosper, and become a major part of the ceremonial life of the people; some are less fortunate, and wane after perhaps only a brief period of activity.

I am firmly convinced that this ability to share with others the benefits of Hopi religious observance, as well as the unique development of characters and performances has given the Hopi much of the strength to resist the abrasive civilization which surrounds them. Were it not for some of the stronger elements of Hopi religion, the people would long ago have been completely swallowed by the alien world which besets them — Indian as well as White. The Hopi are a tenacious people, as anyone who has lived around them will testify.

Erik Bromberg became interested in the Hopi during his service as Chief Librarian, Department of the Interior, in Washington. After retiring from that post, he became a full-time dealer in Indian art, specializing in Hopi pottery, basketry, and above all, Kachina dolls. These latter held a strong fascination for him, and his activity thrived; he has probably handled more *Kachintihu,* to give them their Hopi name, than any other single off-reservation non-Hopi. In so doing, he became aware of the existence of rarely seen Kachinas, and was able to secure representations of some of these little-known Beings. It is from this background that the present book has developed, in an effort to provide a further glimpse into the beauty, mystery and glamor of the masked performances of America's oldest civilization. The author has devoted the last twenty years of his career in exploring the Kachina world, and presents herewith his testament to the fascination of that experience.

<div align="right">Frederick J. Dockstader</div>

Arizona State University
December, 1985

1. Hopiland

Arizona State Highway 264 runs east and west and bisects the Hopi Reservation neatly. On the eastern edge of the Reservation is the major settlement—Keams Canyon. Far to the west are Hotevilla and Bacapi. Then comes Navajoland and through it 40 miles further is the Hopi "island" of Moencopi, just outside of Tuba City. Route 264 curves and twists occasionally and now and then it mounts a hill and soon plunges back into a valley. The stray Easterner may find the naked rocks and stark hills frightening. To the Hopi, to me, the grandeur is not measureable.

The settlements, villages they are called, are all at least 75 miles from one of the borderland cities: Holbrook, Winslow, or Flagstaff, and are strung across the highway with clusters of new, Government-built homes dotting the intervening spaces. Ten miles west of Keams Canyon is Polacca. Polacca has a trading post and one hundred homes. Polacca sits at the foot of First Mesa and perhaps is the first home of the Tewa of New Mexico who fled the Spanish in the late seventeenth century and who were allowed to remain and protect the Hopi who lived above. In time, the Tewa were permitted to come up and were given the far eastern part of First Mesa, which today is called Tewa or Hano. The center of the Mesa is now Middle Village, while ancient Walpi on the far west is the ancestral home of the eastern Hopi.

Moving west, we come to Second Mesa and its old village of Shungopavi and the later-developed Shipaulovi and Mishongovi. Many of the inhabitants of the latter two villages have moved to a cluster of new, government-built houses below. The business center is at the intersection of State Road 87 (to Winslow) and Highway 264 and boasts a large shopping center and a postoffice. On Second Mesa a few miles to the west is the Hopi Tribe's Cultural Center with a museum, a motel, a restaurant, a medical center, and a number of arts and crafts shops.

Leaving the Cultural Center, we plunge immediately to the valley below, pass the new Civic Center, and soon come to the first settlement of Third Mesa, Kykotsmovi (the spelling varies) or New or Lower Oraibi. A fair-sized settlement off the highway, it houses tribal headquarters and a large shopping center. Towering above this village to the west sits Old Oraibi, until recently barred to non-Indian visitors, the oldest continuous settlement in the United States. The less than 200 inhabitants regard themselves as a semi-autonomous state. The philosophy of this village has been given wide publicity by spokesmen such as Thomas Banyaca, so much so that the interested non-Indians of the world have come to regard Oraibi's viewpoint as the outlook of all Hopis, a sad mistake. Hotevilla and Bacapi lie a few miles on further. Like Kykotsmovi, these two villages were founded in the twentieth century. Drive five miles farther west and Navajoland begins once more.

Radiating out of each village—in every possible cranny and for several miles—are the cornfields of the Hopi. The fields with their corn, squash, watermelon, and beans and accompanying fruit trees are a veritable religious mandate for the Hopi.

Corn planting.

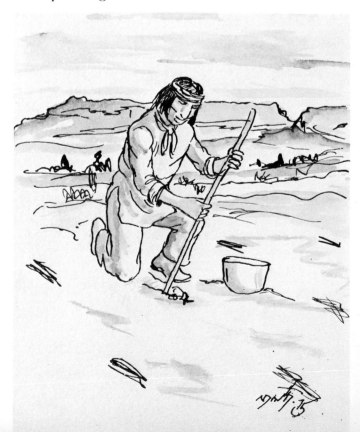

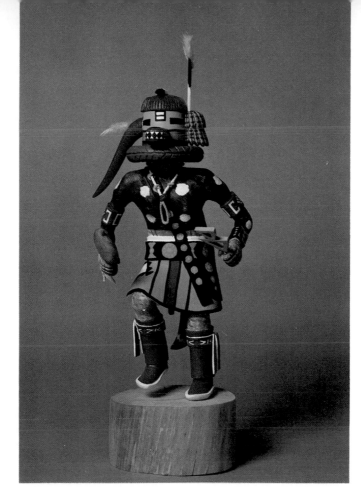

Cat (Mosa) by Ramon Albert, Sr.

Poli Mana by Jim Fred

(Another view of same)

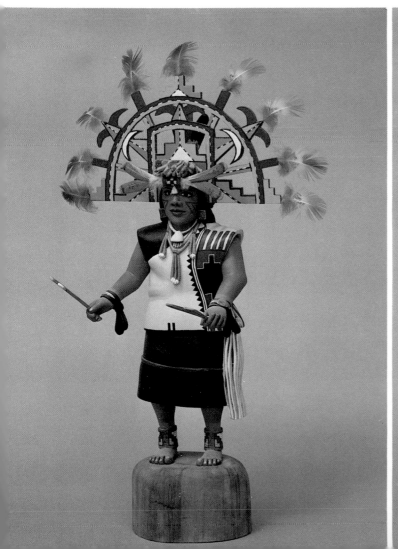

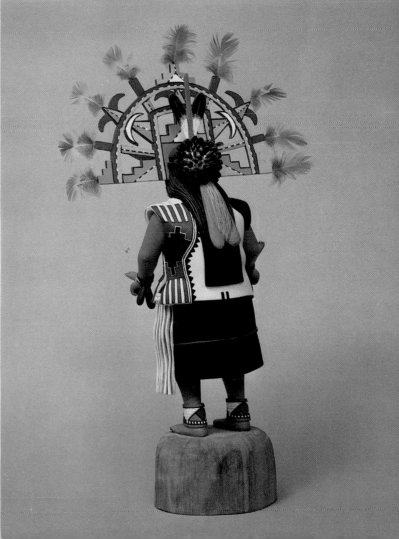

2. The Carver
His Environment, Training and Tools

Their homes span the years. The estate of Charles Loloma, the jeweler, is as up-to-date as any in any city. Not far away are stone dwellings without utilities which have been in use for centuries. The carvers of Kachina dolls live in all types of homes—strangers can find them only by going from door to door. The walls of each of these homes will carry a few dolls belonging to the children. Perhaps not the "thirty, and even more, of the grotesque wooden idols" that Army Lieutenant John C. Bourke wrote about in the 1880's, but at least three to five small figures, usually quite dusty. Incidentally, the very first Kachina doll collector on record, Dr. Ten Broeck, was told in 1852 by his Hopi guide that the figurines were those of saints. Buying by tourists started about a hundred years ago. Lieutenant Bourke describes his shopping spree in Hopi in this manner: "...Moran and myself strolled through the town entering every house and making purchases of idols, baskets, pottery, and other manufactures which cost a trifle for each piece, but in the aggregate, depleted our pocketbooks most woefully."[3]

While Kachina doll carving traditionally has been an activity carried on in the kiva, part of the preparation for some of the estimated 500 dances annually performed by the Hopi, now most of it is accomplished in the home during daylight hours (the village of Hotevilla has no electricity at all). Most of it goes on in the general living area, but many carvers have set up rough "artist's studios." In many cases, these are simple, dirt-floored, unlighted sheds, dependent on the ever-present Arizona sunshine which streams through the open door. Fletcher Healing, noted for his Hano clowns, sits alone at the open door of his tiny studio which looks out at the road. He carves in a carpenter's apron, something not generally used by carvers. Neatly piled outside the door is residue from his work. Like any artist, Fletcher sees to it that there is a balance between the calls on his time by his work and the interruptions of normal living. Fletcher, like most carvers, works on a number of dolls simultaneously.

A few years ago Neil David had a carving group, that is a number of his friends, usually younger and less skilled, who gathered at Neil's studio. It was more than the sewing circle concept, for Neil as a master craftsman did offer advice and encouragement. Carving with company occurs frequently in many homes and it is a pleasant experience for all, including white spectators. Coolidge Roy, a fine carver, says he works alone and as he carves, "He has songs that he chants and hums to himself which seem to help him concentrate on the next cut of the knife."[4]

There exists no course, no curriculum, no training in a formal sense in the art of Kachina doll carving. I can remember years ago asking Alvin James Makyah when his then nine-year-old son would start Kachina doll carving. Alvin replied, "I would say in not too many years! He has started asking questions." Here is the key— Hopis do not push craft production on their children. When the child is ready, the parents receive questions, give answers to the points inquired about, and slowly production begins. Parents never compel a child to learn. The white mother's insistence: "Arthur, sit down right now and practice your piano lesson," has no echo in Hopi. Young carvers draw their initial impetus from older members of the peer group whom they see carving in the group's shed or cave. To be moneyless is to be dependent on others in the group to produce funds for mutual diversion. Once the carver is really skilled, peer group needs have faded and family needs prevail.

The carvers sit at a bench or at the kitchen table. Often a tape recorder is playing a recording of an actual Indian dance. Close at hand is his tool kit and on the bench is his basic tool—the pocket knife. Hopi carvers are very particular about the knife they use. While large dolls are first roughed out with a good butcher knife, the greater part of the job is done with a four- or five-inch pocket knife. Carvers have firm preferences in this area. Brand names sought are K-Bar, Buck, and Old Timer. These are preferred in large part because they are durable. The fine

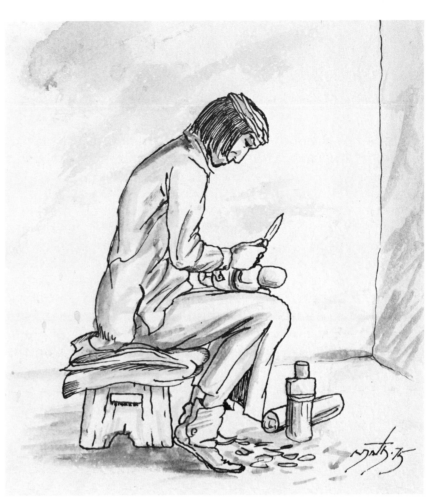

Hopi Kachina Doll carver.

carbon steel used ensures long-lasting edge to the blades. The longest blade of the three in each knife is the most frequently used. The smaller two have blunt or rounded edges, but the long blade is both pointed and angled (biased) so that hard-to-get-to parts of the carving can be reached. A knife becomes more valuable as it is used. Hopis prize the narrow, well-honed blade of a veteran knife. No carver ever abuses his knife and rarely loses it.

The carver's toolbox will also hold one or more rasps, several files, an awl or ice-pick, a light hammer, a nail set, and several small handsaws. Rasps are important to beginning carvers and are used to "rough smooth" the doll after the general image has been formed. Carvers who work on small dolls frequently use an expensive rasp with a hand-hold in the middle of the tool. Awls are used somewhat less than in the past when feathers were placed in holes punched into the doll and glue applied. Now adhesives are so good that carvers often forego the hole and apply the feather directly to the surface. Surprisingly, many carvers prefer a simple ice-pick to the shoemaker's awl, considering the latter "too sharp." Other carvers

bypass an ice-pick and grind a screwdriver down to a point. Files are seldom used, but a small rat-tail file (round) is valuable for smoothing hard-to-reach areas between the legs of the doll. (Others accomplish the smoothing by rolling sandpaper into a tool.) Finally, there are sometimes found in tool kits of some carvers sets of hobbyist wood-carving tools. These are useful with small dolls.

I have mentioned the adhesive used. Today it is almost uniformly Elmer's Carpenter's Glue. Its only disadvantage is the rapidity of drying. The carver must really move fast. Even more tricky is the new "Super Glue" requiring super speed. On rare occasions a carver will use a glue gun. We try to discourage this as the glue is inferior. I can recall selling a batch of cheap dolls stuck together by a glue gun to a dealer in Palm Springs, California. In the window under the fierce glare of the desert sun, they simply fell apart! It is intriguing to think of the carver early in the century who had no adhesives, but carved his dolls in one piece. Those "add ons" like hair and ears were pegged on and so have a low survival rate.

3. Best Carvers

There was a definite drop in the number of carvers in the early 1970's when the U.S. Fish and Wildlife Service was actively discouraging the craft. An Arizona newspaper reported an enforcement officer of the Service bluntly saying that the Indians should find some other way of making a living. Even today the Service continues its pressure as it inexplicably insists that dealers prefer dolls with illegal feathers as they, in the mind of the Service, are in great demand by collectors. This is nonsense, of course.

If a Kachina doll carver were defined as an individual who produces at least a dozen dolls a year, a liberal estimate would be about 350 artists. Of these, perhaps 25% would live on Second Mesa, 40% on First Mesa, and 35% on Third Mesa (to include Moencopi). Women carvers, a recent phenomenon previously unheard of, are common on First Mesa — to list a few, Deloria Adams, Vina Harvey, the Jackson sisters and their mother, Charlene Collateta, Loretta Yestewa, Muriel Navasie Calnimptewa, Elidia Chapella, and Elaine Poola. It is rare to see a large doll made by a woman. In fact, most of the carvers of miniature Kachina dolls are women.

Four Hano Clowns by Fletcher Healing.

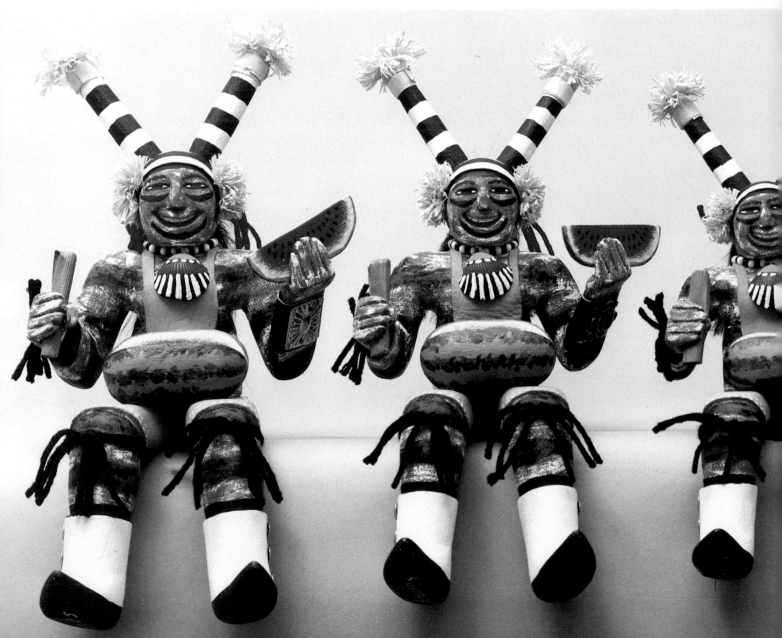

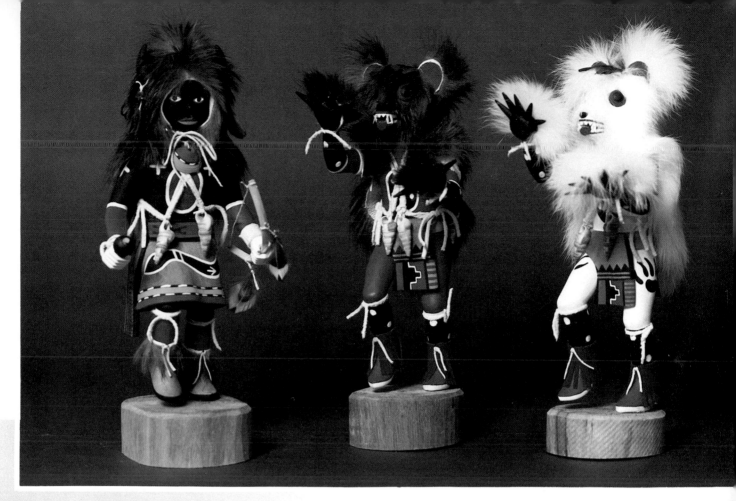

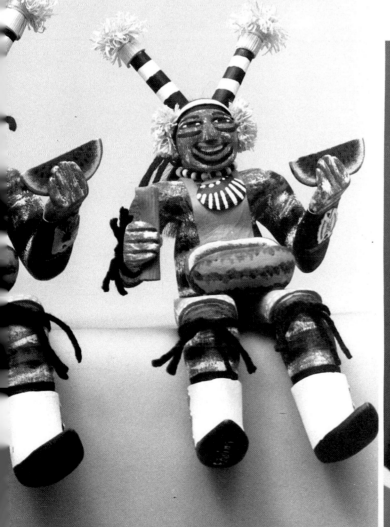

Three dolls by Earl Yowytewa
Detail of Black Buffalo seen above.

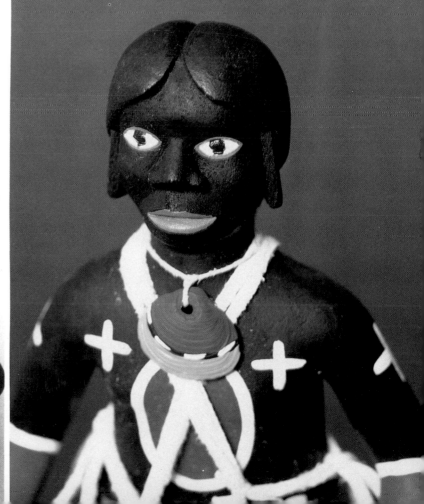

Kachina doll carving is largely a "prime of life" phenomenon. Few excellent carvers are over 60. It is not usual for a carver to reveal superior talents before adulthood, although 15-year-old blue ribbon winner Adrian Poleahla is proof that it can occur. I am sure that Doyle Chapella, son of carver Ernest Chapella, who at under three years of age assembled a doll, may prove to be a very early starter. Carvers can go along in mediocrity and then, as did Lowell Talashoma, Jim Fred, and Von Monongye, in a brief time vault to superior work. The carver, Paul Takala, whose talent was taken from him by a stroke, fought valiantly to live by carving, a fine therapy which kept him alive a number of years. And the carver, Franklin Sahmea, a paraplegic, painfully and heroically makes his dolls, which are quite credible. All "full time" carvers, by the way, develop individual, easily identifiable styles.

The "best carver" list is everchanging. If I were asked to list the best carvers as of January, 1986, not in order of excellence, (and I list only with reluctance because any listing creates an inordinate demand at the expense of young, rising artists) I would have to start with Alvin James Makyah, who is today semi-active. In the history of Kachina doll carving, Alvin must be considered the single most influential artist of the craft. Today, one must look at the works of Von Monongye, Loren Phillips, Lowell Talashoma, Wilfred Tewanima, Arthur Holmes, Amos George, Cecil Calnimptewa, Jim Fred, Peter Shelton, Narron Lomayaktewa, Ronald and Brian Honyouti, Dennis Tewa, and Neil David. Others to be considered are Oren Poley, David, Silas and Coolidge Roy, Earl Yowytewa, Kerry David, Jonathan Day, Lorenzo Martin, Ivan Wytewa, Leon and Paul Myron and Ramon Albert, Sr. See Appendix C for list of all Hopi carvers living on the reservation.

Remember there is no single "best carver." Even crack competition judges disagree here. Barton Wright puts very heavy emphasis on ethnology; that is, on the precision and accuracy in painting (design and color have precise

Neil David, Sr. carving (self-portrait).

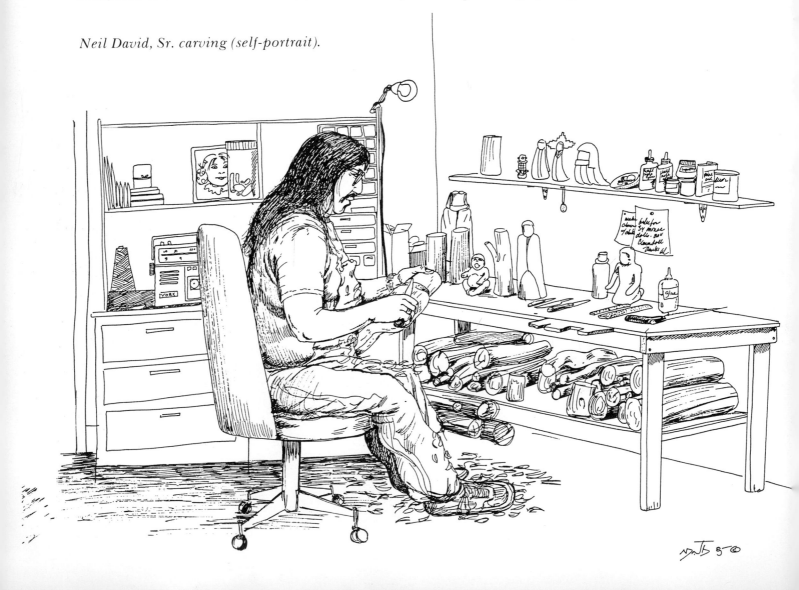

religious symbolism), while Ray Manley, the photographer, seems to look for corporal and textile realism as well as color and line harmony. While the average collector will probably apply Manley's criteria rather than Wright's, a Hopi judge would rule in the same manner as Wright. (The Hopi will also add the affection and empathy he feels toward that particular Kachina figure.) To be authentic IS to be beautiful.

It is well to remember that fifty years ago Kachina dolls were not even considered "art." The Federal Government recognized the carving of Santos by Rural New Mexican Spanish Americans as art and gave the santeros WPA Arts Project support, but no Hopi carvers were similarly helped. (Ironically, the surrealist school of art early this century thought highly of the Kachina doll as an art object. This is discussed fully in an essay by Andreas Franzke in Horst Antes "Kachina-Figuren der Pueblo-Indianer Nordamerikas" which unfortunately has never been translated into English.[5])

Hopi maiden—squash blossom hairdo.

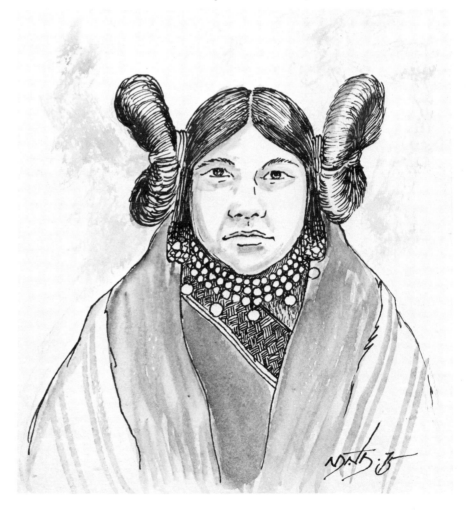

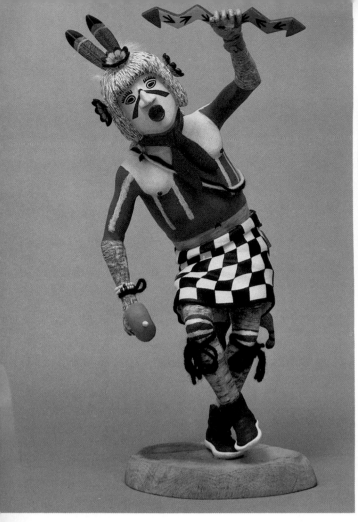

Cross-legs by Wilfred Tewanima.

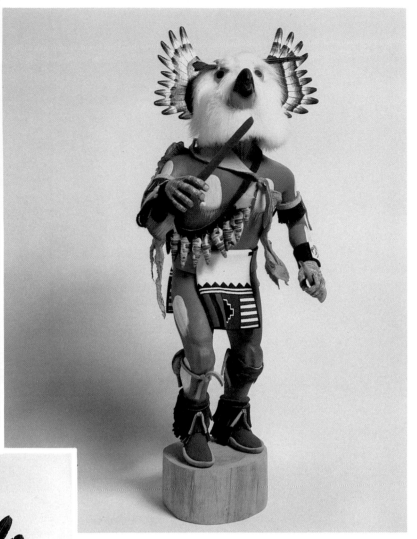

Owl by Narron Lomayaktewa. Courtesy Adobe Gallery.

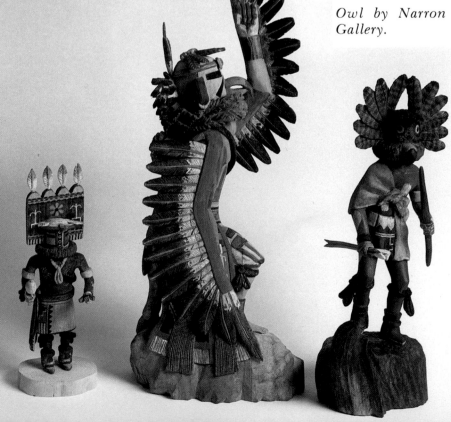

Zuni Hemis by Clyde Honyouti; Eagle by Ronald Honyouti; Owl by Brian Honyouti. Courtesy Adobe Gallery.

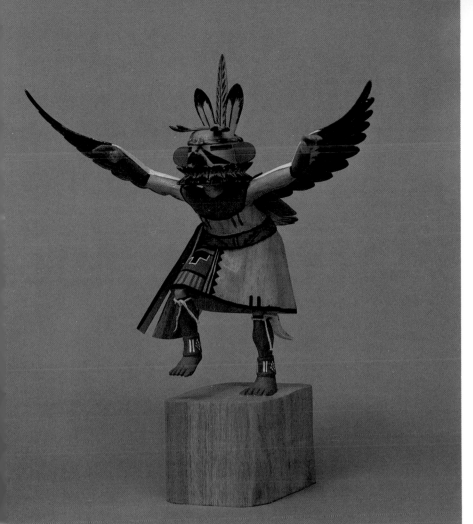

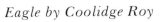

Eagle by Coolidge Roy

Turkey by Muriel Navasie Calnimptewa

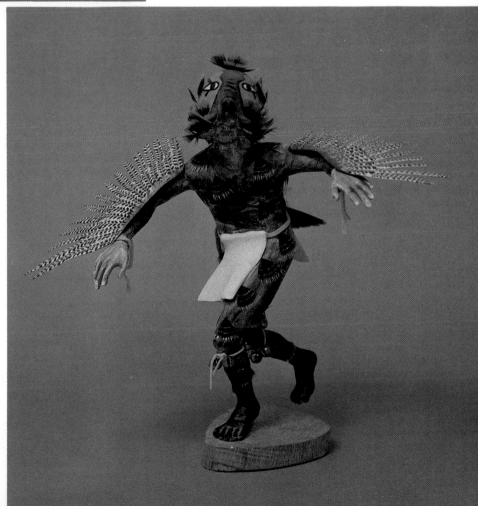

4. Prices of Dolls

Prices of dolls have skyrocketed in this century. Nellie Nampeyo told me that her mother in 1900 had three prices for pots—25 cents, 50 cents, and 75 cents. The 75-cent pot now sells at well over the $5000 mark and is a huge vessel. In the 19th century, Kachina dolls were intended for females and the dolls were simply exchanged for piki bread which the women made. Dockstader (pp. 102-3), speaking of the earliest-collected dolls, observed that they were all flat Shalako/ Pahlik Mana types and postulates that today's Kachina dolls, while owing some debt to the Catholic Santo, may have evolved from the marionettes employed during the Horned Water Serpent ceremony in February. Early clowns satirized the eagerness of the American tourist to pay huge sums for the dolls. Unlike most Pueblo Indians who by and large regard their Kachina dolls as they do prayer sticks, sacred items never to be sold, the Hopi seemed willing to sell from the start. The first recorded "souvenir doll" purchased by a tourist dates back to the middle of the last century. This is a sore spot among traditionalist Hopi today. By about 1900, Kachina dolls usually sold for 25 cents. World War II prices were roughly a dollar an inch. Commercial production is really a phenomenon of the second half of the twentieth century and today prices range up to $10,000. One thousand dollar dolls are now commonplace. It is difficult to estimate the number of dolls carved by the Hopi each year. Production depends on demand just as it did at the turn of the century when the Reverend H.R. Voth was supporting himself by assembling doll collections for a number of musuems. Apparently using quick production techniques by a small number of carvers in a few years he was able to secure over one thousand dolls. Today perhaps five thousand dolls are made annually, but this is only a guess on my part. Incidentally, virtually all dolls are signed today — none were signed 40 years ago. Since Hopi is many miles from a market place, perhaps 95% of all commercial quality dolls are sold on the reservation to dealers. Most of the remainder goes to dealers in the nearby wealthy Sedona, Arizona area. Except for the annual Indian Market in Santa Fe and the Museum of Northern Arizona yearly competition in Flagstaff most Hopi carvers are reluctant to enter competitions. Virtually all offerings at competitions such as the New Mexico State Fair are entries by dealers, hoping for a ribbon to help sell the doll or for a sale at a good retail price. A fine carver such as Von Monongye, Dennis Tewa, Cecil Calnimptewa, Neil David, Sr., or Coolidge Roy may have a one-man show at a good gallery.

Hopi boys at play in plaza.

5. Doll Mysticism

Perhaps a look should be taken at the mind of the carver. There is more reverence accorded by the carver to his Kachina doll than there is accorded, let us say, by the European sculptor for his creation. There exists a kinship of feeling with that of certain medieval painters of religious motifs. Many years ago my wife noticed lying on the shelf of a Shungopavi carver an incomplete, broken, small doll. She thought it would be a good example for illustrative purposes of a doll in progress, so she asked the carver for it. Only with great reluctance did he give it to her— explaining that once he started carving, the object acquired a "soul" and it must never be burned or otherwise destroyed. Others have added that shavings produced in making a doll are not to be burned, but buried, as they too are part of the spirit. The master carver Coolidge

Man entering Kiva, an underground ceremonial chamber.

Roy insists the basic cottonwood root is always full of *wuya* (spirit power) which it sucked up from Mother Earth.[6] A.M. Stephen in 1892 remarked, however, that the doll has no spirit until it is painted.

This propensity of Hopi carvers to assign a vital function to a Kachina doll is not unique to the Indians. A long-time white trader of my acquaintance will sell any form of Indian craft except Kachina dolls. He has had too many "Kachina dreams," he explains, speaking of the appearance to him while sleeping of one or more Kachinas. "Kachina dreams" have occured to other white people. Hopi friends, knowing we have many Kachina dolls, have urged us to "feed the Kachinas," that is, to throw scraps of food into the back yard. As for our death figure—Masau'u—we are urged to keep it surrounded with cornmeal at all times. More on this subject can be gleaned from Frank Waters' book, **Pumpkin Seed Point.**

The following story is told with absolute sincerity and belief by a responsible young Hopi of Oraibi. Several years ago a white trader bought for his home a Piptuka Kachina doll at the Keams Canyon Trading Post. Not too long thereafter the trader appeared at the home of our young Hopi bearing the doll. He was obviously very agitated and begged his Hopi friend to take and keep the doll. The white man insisted that unseen each day, the doll would move about the table in concentric moves. It would never move when watched. The Hopi took the doll and put it on a table in his home and sure enough, it travelled unseen. Then one day it went too far and fell over the edge. It never moved again, but stands still on the table in the house in Oraibi.

It would not be well for any "Western" minded reader to place a value judgement on the depth of belief the Hopis have—a judgement based on scraps of mystical stories. Suffice it to say that to achieve any high religious post or to become a medicine man, an aspirant must put up the life of a dear one close to him. How many applicants to our seminaries and to our medical schools would we have under that stricture?

6. Tihus and Santos

George Mills has attempted to show a parallel development of New Mexico Catholic Santos and Hopi/Pueblo Kachina dolls in his catalog, "Kachinas and Saints, A Contrast in Style and Culture," Taylor Museum, Colorado Springs Fine Arts Center. According to Dockstader on this interesting subject, (pp. 127-128) "...both Santos and Kachinas include representatives of the spirits of individuals who once lived on earth; the use of carved figures of these individuals; the use of ceremonial beings (Kachina, Saints) as intermediaries to bless mortals and to transmit prayers... flagellation either for penitence (Catholic) or purification (Hopi) ...In my opinion, the most marked effect of Catholic hagiolatry is in the small wooden tihu. It is difficult to establish whether the actual origin of these can be attributed to the statues of the saints in the same way the later New Mexico Santos were developed. But it seems likely that the expansion of the tihu into a more sculptural and elaborated art form was greatly affected by the importation of figures of Catholic saints by the priests, who realized that by the gradual introduction of similar religious features, Catholicism might in time replace the native practices."[7]

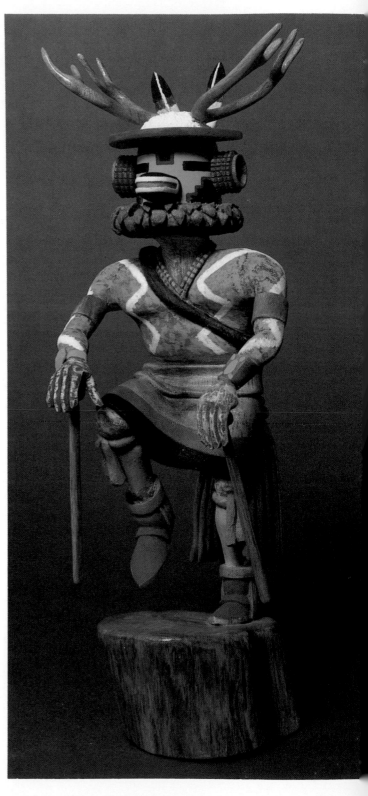

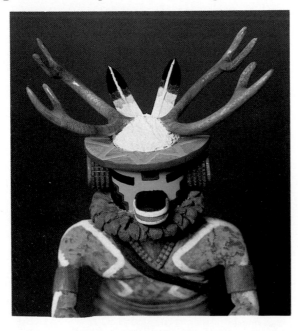

Detail of same.

Deer by Michael Talahytewa.

7. Carving Techniques

As the carver sits at his bench ready to carve, what determines which Kachina figure he is about to make? There are several hundred to choose from. Some carvers are entranced by one figure and make it over and over again. One First Mesa carver is known to have produced only the dread Masau'u. One of his neighbors, a sensitive artist, turns out one delicately made Whipper after another, perhaps 75% of his total output.

Many carvers meditate over the wood they are about to use. Frequently, the artist will confide that the wood instructed him as to the nature of the doll. A crooked piece of wood sets a problem before the carver for it invariably calls for the end product to be an "action doll."

Customer demand, upcoming dances, and plain inertia in most cases determine what the doll is to be. The white man's limited vision makes him seek out the familiar clown, Mudhead, or ogre. Animals and birds—eagles, owls, foxes, and the like—are familiar to the customer, so he tends to purchase them. Occasionally a doll becomes so popular, as in the case of Fletcher Healing's seated clown, that the carver turns out nothing but that figure. In a good many cases it must be said that the carver simply leafs through the Wright/Bahnimptewa book until he finds a likely subject. This book has been highly influential in Hopi doll production.

The carver's medium is wood. To be precise, it is the waterseeking root of the cottonwood tree—a common sight in the Southwest, especially along streams. The U.S. Forest Product Laboratory has determined that rootwood is much less dense than branchwood and also much less susceptible to "tension wood" which causes warping, checking, and fuzzy grains in branches. A technical analysis of the cottonwood by the Laboratory observes: "The cottonwoods are prone to warping, but their shrinkage is moderate. They glue satisfactorily (plywood), have low nail-holding ability, do not split easily, and hold paint well. They have a sour odor when moist but are odorless and tasteless after seasoning."

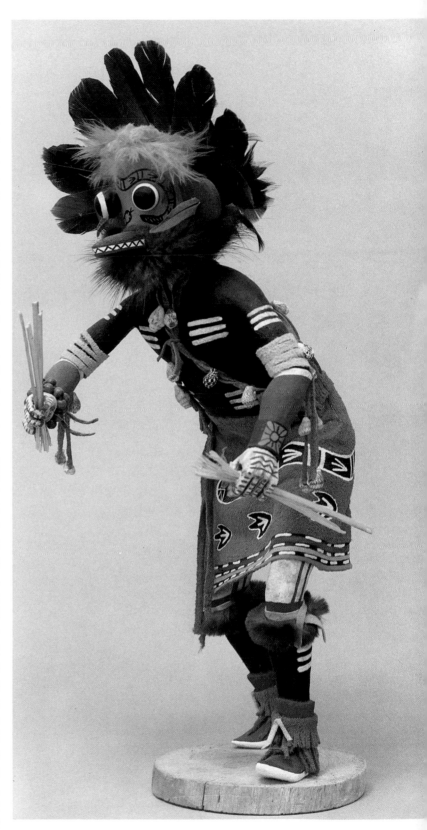

Situlili by Ernest Chapella. An example of carving to accommodate bent wood.

Roots are highly prized as there is a shortage of supply. The Hopi have scoured their lands and little is left. They have tried the Cottonwood, Arizona area and White River Apache area. Today Navajos often use pack horses to go back to inaccessible areas to bring out the roots. (Only dead roots are sought.) Once home, the Navajos scrub and clean the roots and cut them into saleable pieces. A prime root five inches in diameter and five feet long will bring $20 or more. Since Colorado has a good supply of first quality wood along its streams, white traders have for years brought a quantity to trade or sell on visits to Hopi.

A prime piece of root for carvings is smooth, straight, and pinkish in coloration at the cut. Its weight is much less than an equal length of branch and much more than an equal length of a poor substitute—balsa. Carving a piece of branch is a really arduous task, for the wood is unyielding. Balsa is too soft, even a fingernail will dent it. Large dolls require a root of four to six inch diameter. Smaller roots are used for dolls under eight inches tall.

Steps in Doll Construction

1. **Rough cut** *First Mesa:* If the doll is to be large, a butcher knife is used to rough out the general shape. *On Third Mesa,* it is also quite common to rough out the shape with a bandsaw and template.
2. **Rasp** Rough cut is brought under control with vigorous use of rasps. Experienced carvers shun the rasp.
3. **Fine cut** *The First Mesa* carver employs a simple pocket knife to flesh out the figure. Clothing simulation in the wood is done at this time. *On Third Mesa,* some carvers use a hand-carried multipurpose power tool in this work.
4. **Sanding** Coarse sandpaper is used to start. For example, Neil David buys sandpaper belts, cuts them into sections, and thus has a natural curve to fit around his fingers. Fine sandpaper is used to finish the job. It is in the sanding that we see the major difference in carvers—good carvers spend extraordinary time on this step. Hard-to-reach areas such as between the legs are reached by rolled sandpaper or a small rat-tail file. For small dolls, simple board nail files are known to be used.
5. **Whitewash** A coating of whitewash is now applied over the doll. In earlier days, this coat was a wash of clay. Today it is either Gesso, Spackle, or simple flat latex paint. After application, the doll is left to dry thoroughly. Sometimes the oven in the kitchen range is used to speed drying.
6. It is at this point that First and Third Mesa techniques often diverge. Here, *Third Mesa* carvers begin to achieve their slick finish. Once the whitewash is dry, some Third Mesa carvers may sand it with fine sandpaper. A clear varnish sometimes is applied lightly and allowed to dry. Then fine sand, then varnish, then again fine sand. Other *Third Mesa* carvers use the sequence of sand, whitewash, and sand. Many *Third Mesa* carvers like top ones on *First Mesa* achieve their effect by a grueling fine sanding job.
7. **Glueing of limbs, head, and applied accessories** Arms and legs and sometimes the head, which have previously been prepared, are affixed with Elmer's Carpenter's Glue. Accessories such as sashes and belts, which have been carved separately, are also glued into place. All joins are fine sanded to invisibility. Hair may be displayed by carving, applying fur or actual hair, or by a Gesso mixture.
8. **Painting** Today only the rare carver uses anything except acrylic paints. A few, like Tino Youvella and Leo Lacapa, use simple flat latex. In earlier days, tempera was used and before that, earth colors plus chewed seeds mixed with saliva. When the rare, naive Hopi accedes to the request of a rogue trader to make a counterfeit "old" doll, it is an easy matter for him to carve in the old style on poor quality wood, whitewash with clay, and use earth colors mixed with clay to paint with. Acrylic paint is uniformly applied with a good brush, sable or camelhair, though on large dolls overall colors can be applied with a cheap brush. I know of no carver who still paints with a chewed yucca stalk as his fathers did. Many carvers paint from jars of the acrylic, but others object to the jars, as the quick-drying acrylic will dry in open containers. These latter carvers use tube paints and squeeze out what is needed immediately onto a palette, which is also a mixing board. Wilfred Tewanima, the eminent carver, avoids the problem of painty fingers marring the body when painting head and legs by wrapping the torso completely with a soft rag. "Natural" finish dolls are frequently decor-

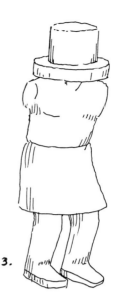
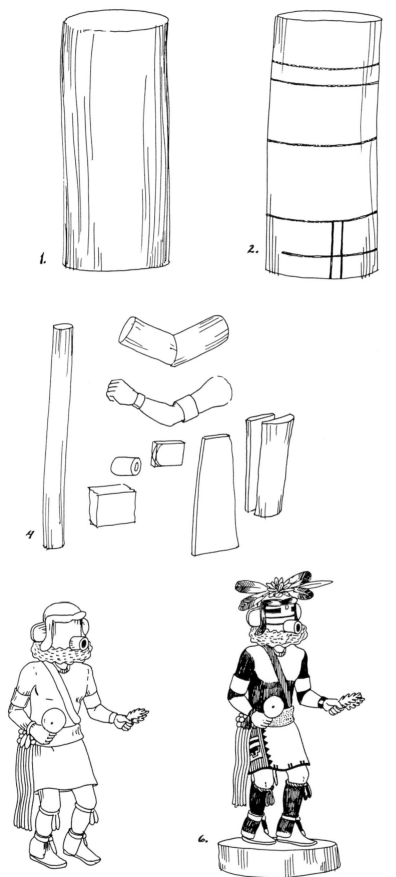

1. *Cottonwood root, knot free (if possible) and crack free. Cut to desired length. 10" —12" average size.*

2. *Saw cuts to start doll—head, ruff, and bodys' kilt cuts are completely around the wood about 1/4" to 1/2" deep (depending on diameter of wood). Feet cut is about 1" and is cut on the side you decide to face your doll. Usually one cut vertical from the base of the wood (feet side) is sufficient.*

3. *Rough carved figure. At this point pieces to be added are measured and prepared, like filing a flat piece on the right side of the kilt for the sash, and marking where the mouth (snout) and ears will go.*

4. *Small root pieces are excellent for making the arms and mouth. Splitting small pieces in half works to make ears, sash, and rattle pieces.*

5. *Arms, sash, and ears are added. Leg ties, bandolier, leg fur (ankle) and head band are carved on. Doll is sandpapered and primed to be painted.*

6. *Completed doll, painted and mounted on piece of sanded root, about 1 1/2" —2" thick. FEATHERS are put in place after the figure is completely painted. Should carver feel feathers are to be of wood, then they are made in step 4, and finished and put on in step 5.*
Drawings by Neil David, Sr.

ated by use of a burning tool which etches out designs.

9. **Accessories** The final step is to put into place the accessories which have been prepared beforehand. These include rattles, turtle shells, braided muffs to simulate evergreen, yucca whips, bows and arrows, rabbit sticks, piki, dance wands, and the like.

10. **Base** At this point, the doll is placed on a cottonwood round which is held in place by glue, peg, or more frequently, a finishing nail. The base, by the way, is a recent development. In the beginning, Kachina dolls simply hung by string from the house rafters.

To illustrate how little the basic processes have changed, Stephen in 1893 said, "Of tools, the pocket and hunting knives are used by all. They have also a handsaw and a small Mexican adze, one or two pieces of hoop iron with notched edges for use as saws, a wood rasp, and numerous files of all sizes and numerous awls. Fragments of sandstone are used to obtain a finished surface on the figurines after carving." Surprisingly, Stephen also indicates that aniline paints were occasionally used then! Spaulding, writing in 1953, insists that the art of Kachina doll carving is in decay due, in part, to the use in recent years of white man's tools!

Below: Hopi Baskets with Kachina designs.

Right: Crow mother by Coolidge Roy. Note the yucca whips used in initiation.

Far right: Comanche by Paul Myron. Courtesy Adobe Gallery.

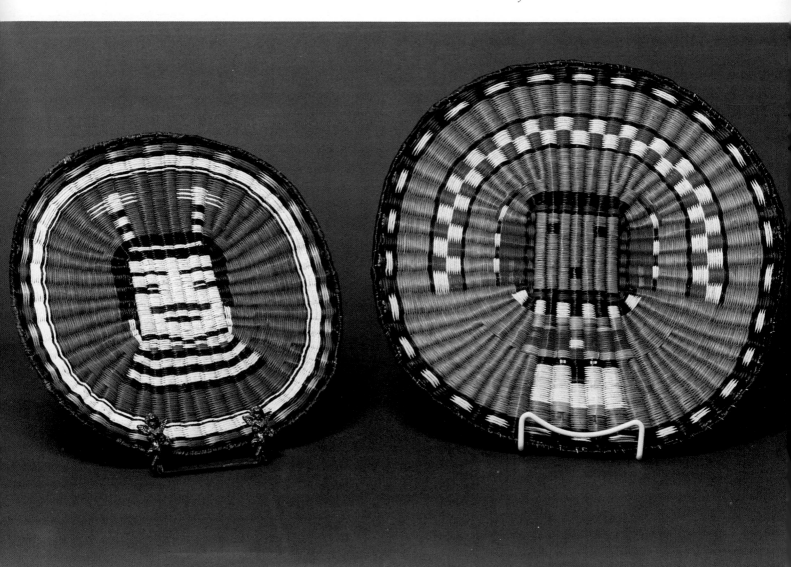

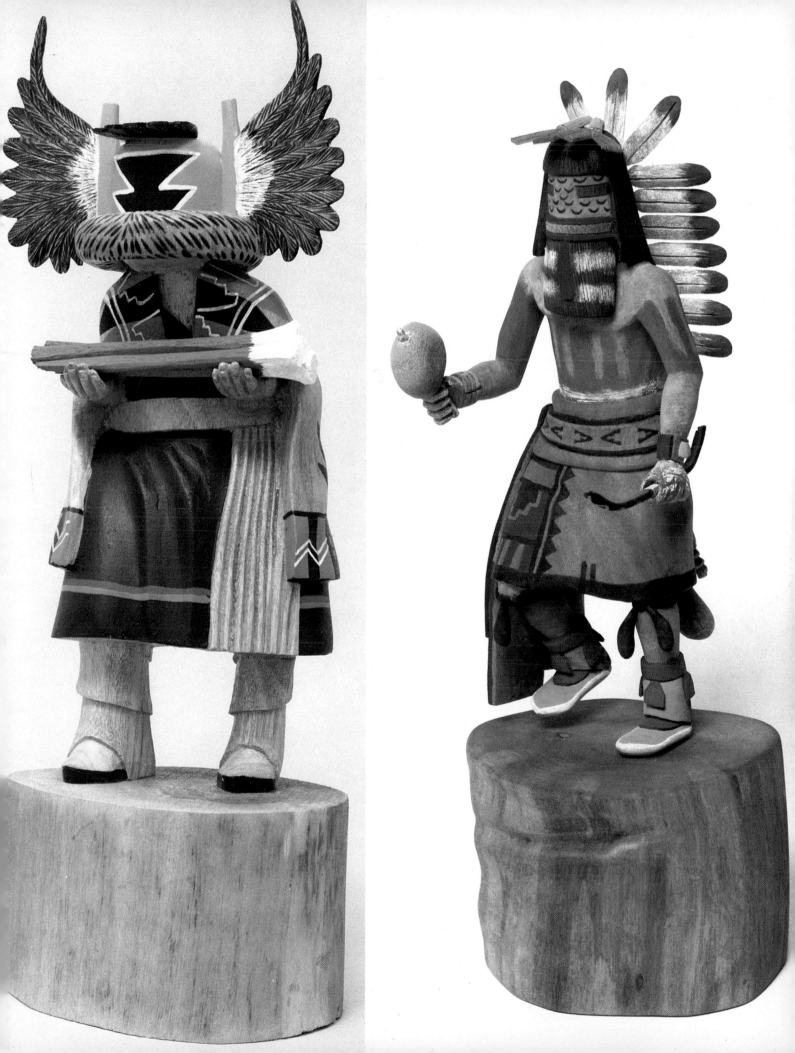

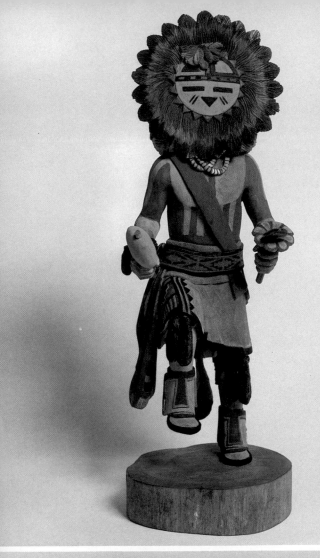

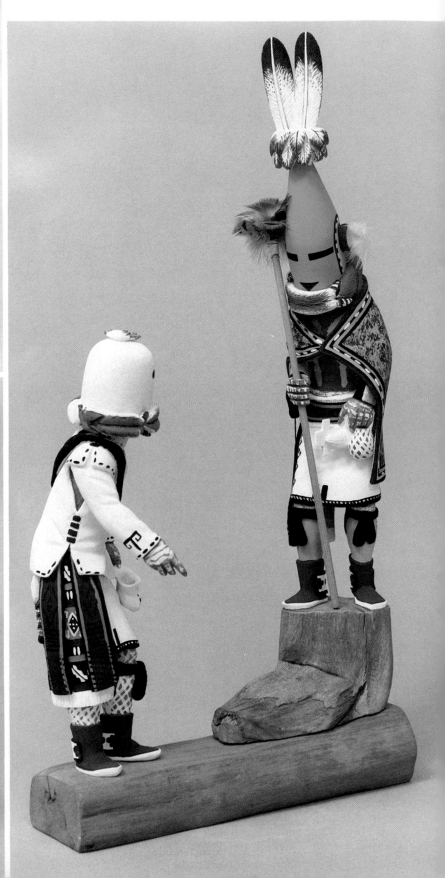

Sun by Kerry David. Courtesy Adobe Gallery.

Sun Priest by Peter Shelton. An example of a doll few carvers would make.

Eototo/Aholi by Lowell Talashoma. The premier Kachina and his Lieutenant.

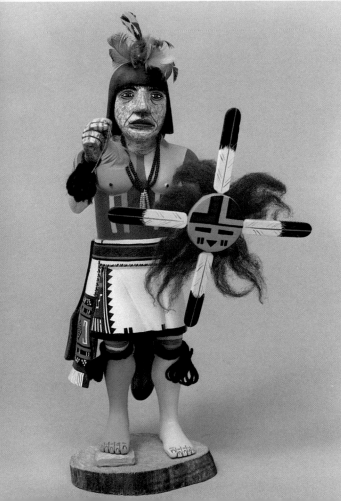

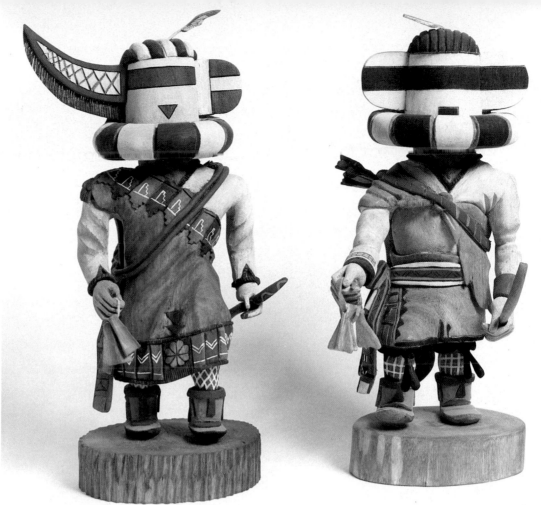

Sai-astasana by Leon Myron and Hututu by Bennett Sockyma. Courtesy Adobe Gallery.

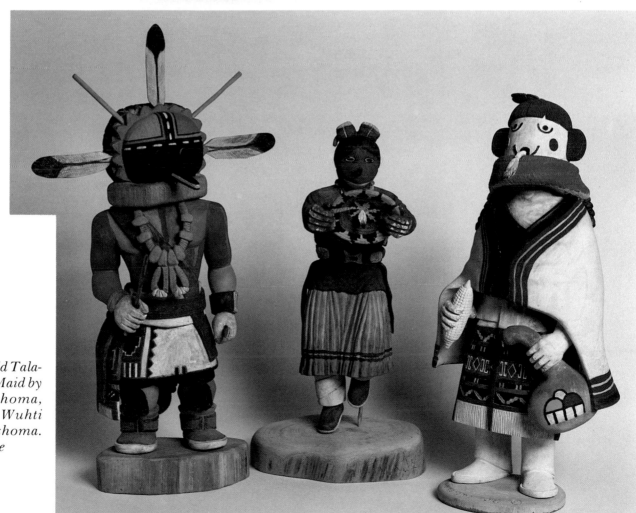

Wupamo by Todd Talashoma, Navajo Maid by Wilburt Talashoma, Jr. and Ha-Hai Wuhti by Lowell Talshoma. Courtesy Adobe Gallery.

8. Kachina Doll Styles

The divergence of methods of First and Third Mesa carvers (see section above) has produced doll styles not too hard to differentiate as to area (and even carver). Third Mesa use of mechanical tools, plus their finishing techniques, has resulted in a doll which appeals very much to the white collector. The average collector, used to mechanically-made perfection in the products he buys in his world, has a hard time accepting the completely handmade. The handmade Hopi pot with its off-center quality and its fire blush is very suspect to the uninitiated. Similarly, the "crude" First Mesa doll which tries to project the true Hopi figure, using simple production methods to achieve this end, usually comes in second. All of this is the legacy of the Third Mesa carver, Alvin James Makyah of Hotevilla. Alvin's work is as distant from that of his grandfather as Joseph Lonewolf's world-famous modern pottery is from the pottery of his grandmother.

Alvin is by training a cabinet-maker. And he has long been absorbed in the close study of human anatomy for application in his art. Early in the 1970's he applied his cabinet-making skills and his knowledge of anatomy to the White Buffalo doll. The White Buffalo only recently appeared in a First Mesa social dance. In the mid-1960's Tino Youvella was noted for his White Buffalo doll. Alvin's White Buffalo was an instant and phenomenal success. After that, Alvin became the instructor of many of today's top Third Mesa carvers in his methods. The action-filled, smooth, finished, crisp-colored doll to be found on Third Mesa is a direct result of Alvin's pioneering efforts. The "action" doll is not Makyah's invention, but started to evolve in earnest about 1950, with the term, "action doll," first appearing in print in 1958, according to Litman. Today there is a trend toward the wood sculpture with a definite Kachina motif. A

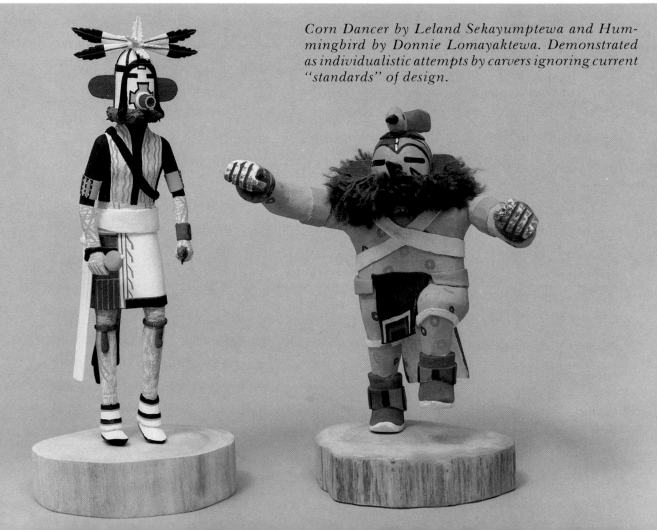

Corn Dancer by Leland Sekayumptewa and Hummingbird by Donnie Lomayaktewa. Demonstrated as individualistic attempts by carvers ignoring current "standards" of design.

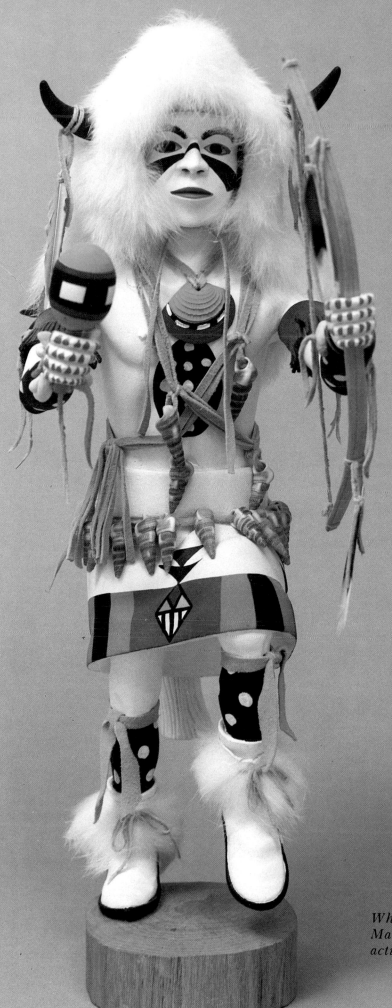

White Buffalo by Alvin James Makyah. This is a pioneer action doll.

misshapen split root somehow becomes a Shalako pair. A long piece of wood is carved the length with a variety of Kachina themes. A hand holds an ear of corn. Neil David seems to have been the originator of this recent development.

One caution: Try not to assign a definite year to the advent of a change in style of carving. Erickson, who has done the best history of stylistic changes in Kachina doll carving, emphasizes this. Never assume a style change indicates that all Hopi carvers have changed. There are carvers today who carve as they did forty years ago. And there were early advances which simply never took hold. Perhaps the most sobering sight for one who thinks he knows Kachina doll history is the pre-1902 photograph by Adam Vroman of the interior of a First Mesa home, "Hooker's House," which clearly shows a huge "action" Kachina doll. It appears to be a seated Hano clown, legs akimbo, carved thirty years before the birth of Neil David, whose clowns today in that style are famous. (Compare Hooker's clown with the 1901 seated Mudhead illustrated in Hartmann #50.) Plate XV (page 142) of Dockstader shows a Jimmy Kewanwytewa doll with as much action as any today.

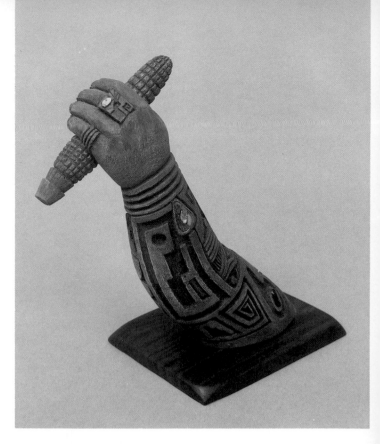

Sculpture by Neil David, Sr. A prayer for a good harvest.

Longhair and Longhair Maid. 1984 bronze figures by Lowell Talashoma. Edition of 50. Courtesy Adobe Gallery.

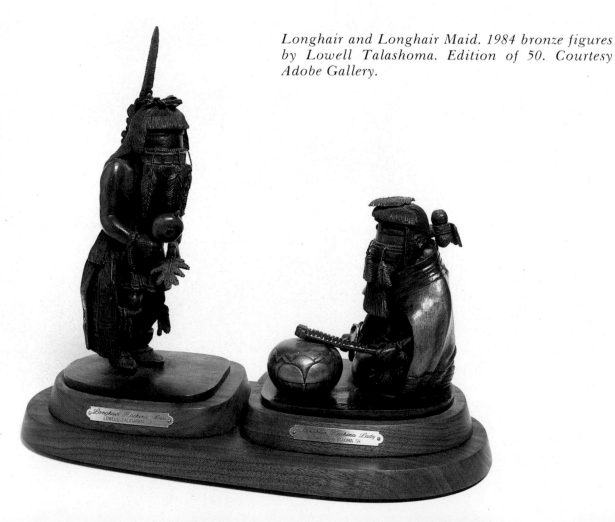

Alvin James Makyah in the mid-seventies attempted a bronze of a Kachina, but he was very uneasy with his creation. Litman reports that he seems to have felt that he, in a manner, cut the last religious link to his work in this appeal to the white buyer. (Dockstader comment, "A bronze can in no way ever be called a Kachina doll.") A short time back, a white promoter signed up Neil David and Lowell Talashoma on an exclusive contract, now not in effect, to produce these metallic dolls as well as ceramic ones, and they reportedly sold well. They appeal more to collectors of western art rather than conventional Indian art. For a more detailed account of recent developments in the art of Kachina doll carving, the reader is directed to Barton Wright's article in *American Indian Art*, "Kachina Carvings," Spring Issue, 1984, pages 38-45, 81. Finally, it should be emphasized that the white buyer has set carving styles and techniques. Left to their own needs, the Hopi carvers of today would be carving as their grandfathers did.

The question, "Is the Hopi carver really producing Kachina dolls today?" may be raised. White collectors are clamoring for dolls done in the natural tone style originated by Ronald Honyauti. If one removes religious symbolism indicated by colors as one has already removed symbolism indicated by eagle and other banned feathers, is the end product still a Kachina doll? Bruce McGee of the Keams Canyon Trading Post predicts that only few of the top twenty carvers will employ paints heavily but rather they will use principally stain and burning tools. Traditional dolls, however, will continue to be produced, according to him, by the majority of the other carvers. Is this what Spaulding meant when in 1953 he said (page 3): "In recent years the art (of Kachina doll carving) has been victimized by the tourist trade and we find numerous Hopi craftsmen manufacturing the dolls for sale rather than the originally intended purposes as gifts for children... Hence, it may be surmised that the art has been dealt the death blow. The original and honest intent for their existence in most cases is absent. Quality has been replaced by quantity. Honesty has given way to mercantilism. Symbolism has lost its meaning and has fallen to the ranks of pure decoration."[8]

Under no circumstances should the above discussion of methodology and style leave the impression that procedures in creating a doll are fixed as described. Nor do all carvers of First Mesa or Third Mesa carve in the styles discussed. It must be remembered that we are, after all, dealing with artists.

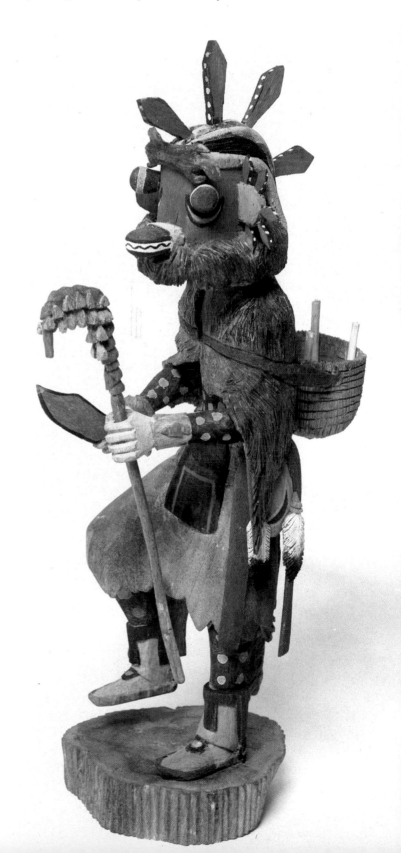

Scavenger by Delbert Silas. A rare figure supposedly depicting a looter of the ruins of Awatowi.

9. What is a "Good" Kachina Doll?

There are no critical textbooks on Kachina doll carving, those which detail in depth the characteristics of a good doll. Perhaps, given the variety of tastes, a course in the appreciation of Kachina doll carving simply would not be feasible. It is significant, however, that there is not one museum in the United States which has an updated collection of Kachina dolls carved by contemporary artists!

Some years ago, the researcher Litman[9] asked a number of reservation inhabitants just what in their minds constituted a "good" Kachina doll. The answers she received covered the spectrum—from that of two young Hopi women who averred that any traditional doll was beautiful because the meaning embodied in the doll was beautiful, to the usual listing of technical accomplishments. My experience with this form of inquiry brought these interesting observations: Bruce McGee of the Keams Canyon Trading Post—"My thought on first seeing a doll is: does this doll faithfully reproduce the actual dancers I have seen? Does it have a lifelike, realistic quality? To assess the carving, I start with the hands. If the hands are well-done, inevitably the rest of the doll will be well carved and usually will be precisely painted." Von Monongye, one of the top five Kachina doll carvers and also a dealer in Kachina dolls by other carvers says, "I am a stickler for completeness. So I look to see if every small part of the doll is complete as far as carving, sanding, and painting is concerned. I expect any good doll to be authentic, that is, to remind me of actual dancers I have seen throughout my life." But the artist Neil David takes a different approach—reflecting in part the view of most Hopis who are reluctant to judge the carvings of other Hopis: "I cannot assess the quality of someone else's doll. The usual judging statements—faithful in detail, feeling of action, completely carved, and so on, are traders' criteria. I can relate only to a doll I have carved because of the inner feelings I have for the Kachina depicted.

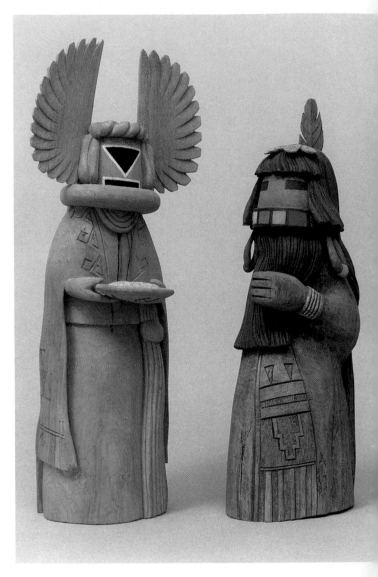

Sculptures by Neil David, Sr. Crow Mother and Longhair.

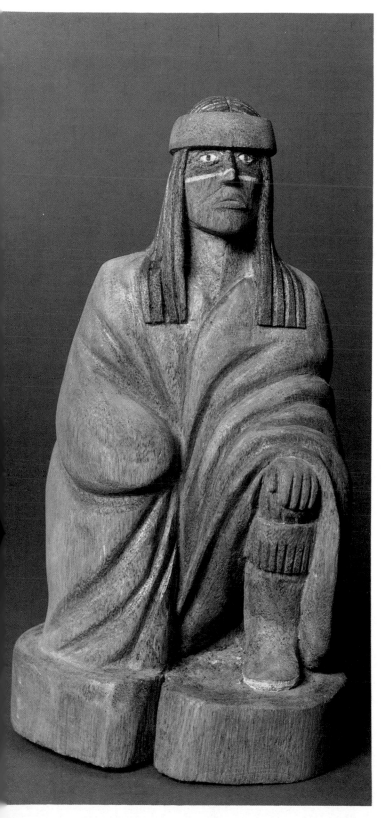

Apache by Cleve Honyaktewa, a sculpture.

The mechanical aspects are completely secondary!'' Incidentally, a census, if taken today of collectors of fine contemporary dolls, would agree only that a good Kachina doll is a finely crafted, all-wood creation. Perhaps a wood sculpture.

My recommendation is for the collector to consider many of the same points he would look for when critiquing a piece of sculpture. Anatomical realism or deliberate satirical overstatement is an obvious point. However, do bear in mind that the head of a doll is often over-emphasized both to indicate a mask and to better show off vital facial symbolism. Simple craftsmanship is necessary, such as painful sanding and accurate lines. Painting, of course, must be faithful in reflection of the paint used for the actual dancer. Accuracy in the dance step demonstrated and in the accessory carried is important. In the latter respect, however, it simply is not practical to use evergreen boughs as the actual dancers do, nor similarly perishable piki bread found in the hands of clowns. The masks and costumes are, of course, critical. Finally, as a simple tip, the viewer is advised to examine the hands of the doll. The skill of the carver here will predict his skill elsewhere on the doll.

The painstaking care and skill in carving in products of artists like Cecil Calnimptewa or Jim Fred are evident even to a freshman observer. Jim Fred's facial and body characteristics are superb in faithfully depicting the Hopi figure and face. He does not attempt to pander to the non-Indian criteria of beauty. Calnimptewa excels in carving costume folds and he has taught his techniques well to Dennis Tewa and Loren Phillips. Simple beauty is an obvious plus and this is found in the natural wood tones of Lowell Talashoma and Von Monongye. Ronald Honyouti is noted for his one-piece carvings, that is, carvings in which all parts of the doll, including the accessories, are carved from one block and no adhesives are used. Honyouti is also skilled in natural wood tones.

10. The Kachina Doll and Legend

Beginning collectors of Kachina dolls always ask the carver or the dealer the same question: "What is the story of this doll?" Since most dolls represent performance in a given ceremony or social dance, this is a question hard to answer elaborately. What is a Velvet Shirt? What is a Chipmunk? Most figures simply represent ceremonial participants in procession or as dancers or side figures, guards (whippers), or clowns. Figures may also be those of social dancers—example, the White Buffalo.

Of course, some Kachinas have solid stories, usually legendary, behind them. The Hé-é-e is the representation of a Hopi heroine who, while putting up her hair, was given the news that the enemy was attacking. With one hair bun up and the other streaming, she rushed out to lead the Hopis in beating off the attack. The Tuhavi is a paralyzed figure usually shown with a blind Mudhead, his brother. Again, the enemy was attacking and the Hopis had fled, leaving behind the paralyzed one and his blind brother. The blind one put his paralyzed brother on his

Hé-é-e by Richard Dewakuku. Courtesy Ruth Fifield, Santa Fe.

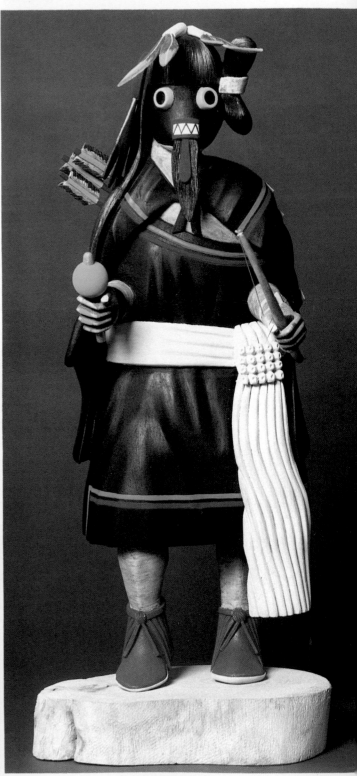

Detail.

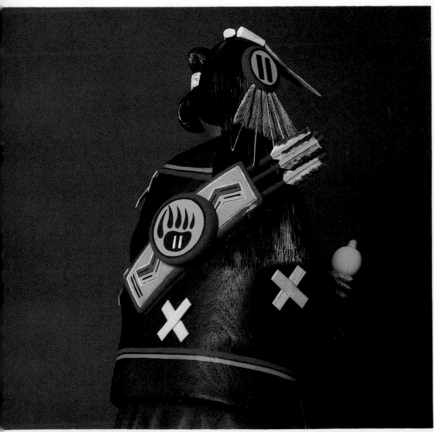

shoulders and with the eyes of the paralyzed one to determine direction and his arms to use the bow and arrows to hunt, they eventually reached safety. Estevan the Moor is an historical figure—a slave in an early Spanish exploring party in what is now New Mexico and Arizona. I believe he is the earliest black to be mentioned in American history. When the party approached, Estevan was sent forward to test the waters, as it were, for safety. The Zuni promptly stoned him to death and later made him into a Kachina—the Chakwaina. Another figure out of Spanish history is said to be Yowe, the Priest Killer. In 1680 in the village of Shungopavi, Yowe was the Hopi who seized and killed the Franciscan priest (he beheaded him) during the Great Pueblo Revolt. Oral tradition among the Hopi has it that the slayer did not execute the priest for religious reasons but rather because the priest had appropriated his girl friend. I have owned a Yowe carving dragging a girl by the hair with one hand and holding the severed head of the priest in the other.

Another Kachina with a story is the Half-Clown. The Corn Dance is a very serious matter. In this instance, a dancer was both straying away from the line and in general making a fool of himself. In time, lightning struck, and when the dancer regained consciousness his face was split vertically—on one side he was a clown and on the other side he was a Corn Dancer. Another version has it that lightning struck the Corn Dancer and a clown and when the Hopi tried to make them whole, they botched the job and made two half-clowns. On First Mesa, the Half-Clown tries to make the Hopis live a correct life and he beats a drum slowly to mourn their transgressions.

Piptuka is reminiscent of Half-Clown. Not a Kachina, but rather a gentle reminder to the Hopi of his neglect of nature and of fellow man. Piptukas emerge to put on a kind of morality play. For example, the Piptukas, adorned with the antennae of bees, may act out the Hopis' lack of respect in not setting out prayer feathers for the bees—that is, a failure to pay respect to all

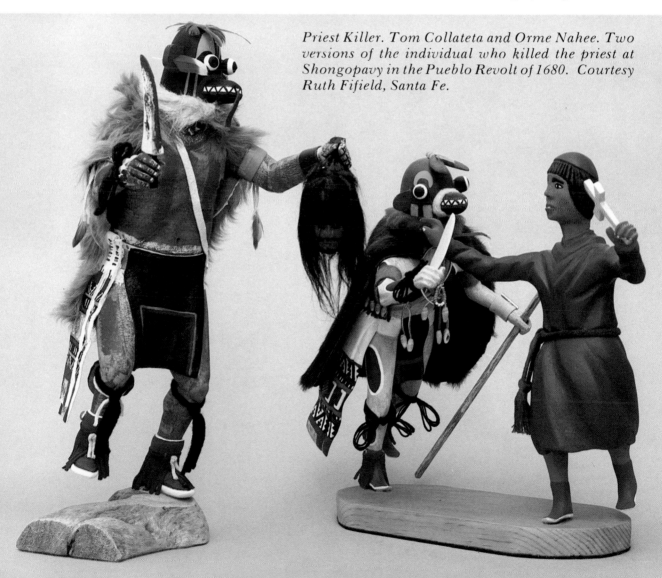

Priest Killer. Tom Collateta and Orme Nahee. Two versions of the individual who killed the priest at Shongopavy in the Pueblo Revolt of 1680. Courtesy Ruth Fifield, Santa Fe.

features of nature. Thus, a Piptuka, commonly assumed to be only a farmer, may emerge in a multitude of costumes, depending on the character to be depicted.

Not too long ago, I asked Neil David to make me a Mouse. The Mouse is not a dance figure at all, but rather the hero of a Second Mesa legend. A mouse undertook to rid the village of a pesky chickenhawk. This he did by taunting the hawk and eventually tricking him to dive into a stake and impale himself. The Warrior Mouse, as he is called, is not to be confused with the Mickey Mouse which has no Hopi roots at all. The latter falls into the same category as the Elephant Kachina doll some political zealots had made some years back. Several other stories are detailed in Elaine Baran Holien's "Kachinas," in *El Palacia*, Vol. 76, No. 4, Sept 1970, pp 1-15.

The question is frequently asked: "Is it possible to collect one of every Kachina doll? Since no one can really identify every Kachina figure and social dancer, there is no way to obtain a "complete" set. Few carvers are familiar with more than a small percent of all figures. If you do choose to obtain an obscure doll, and if your supplier pleads inability to help, ask him to write to Elmer Adams, General Delivery, Polacca, Arizona 86042. Elmer is a carver of very moderately priced dolls. I find that his repertory of obscure Kachina dolls is far greater than that of any other Hopi carver. I would suggest your dealer enclose a stamped return envelope and if possible, a picture of the doll desired.

Mouse by Neil David, Sr. This mouse is the central figure in a Hopi folk tale.

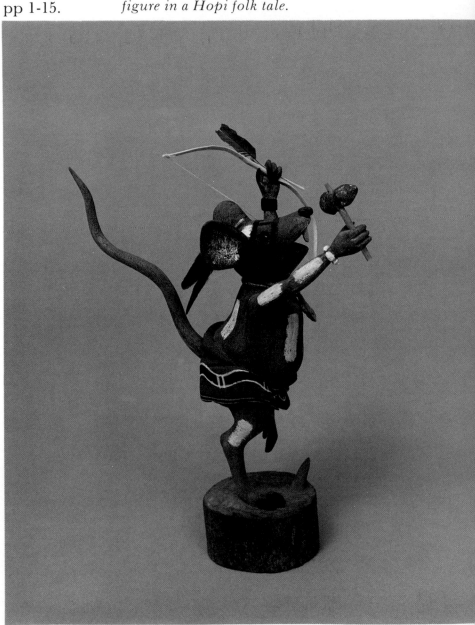

11. Kachina Doll Collections

A collector aiming for a fair-sized collection cannot insist only on "story" dolls or a "complete set." Collections may have many directions. A simple theme comes with the collection of the works of only one carver. Thus, one specialist may buy only the works of a particular artist-carver. There are several collectors of the one-piece works.

It is inevitable that there be collections of pornographic dolls. Since the violent death a number of years ago of the premier carver of such dolls, Heber Andrews, most products in this category have been unimaginative and dull. The Hopi approach to sex is different from the white man's. Much of our attitude derives from a prudish Puritan background. Procreation is an immeasurably important force in Hopi culture and the approach to copulation takes on a religious significance. Stephen notes in his 1893 journal that a five- or six-year-old Hopi boy, at the urging of his father, sang a little song about the relationship of the penis, the vulva, and sexual desire. Clowns and others have frequently simulated intercourse and clown horseplay has involved pulling an individual about by his penis or sitting on him and pulling out any pubic hairs he might have failed to remove (as is the custom). Hopi audiences have roared with laughter at this horseplay. Kachina dolls are presented to girls as a wish for and an aid to conception, but in truth, dolls with an obvious sexual motif are made only to titillate the white man and to have him buy. For those wishing to learn more about Hopi sexual attitudes, read Dockstader.[10] He shows how natural genital exposure by the Hopis was transformed into puritan modesty by white disapproval. So far did this modesty go that the 19th century Kokopeli with a natural penis became a fully-costumed dancer wearing a huge wooden penis over the costume.

Collections are best built in certain natural categories. The clown is a very popular actor during Hopi ceremonies. Each area of Hopi has its own clown. It is a mistake to regard the familiar striped Hano or Tewa clown as the only

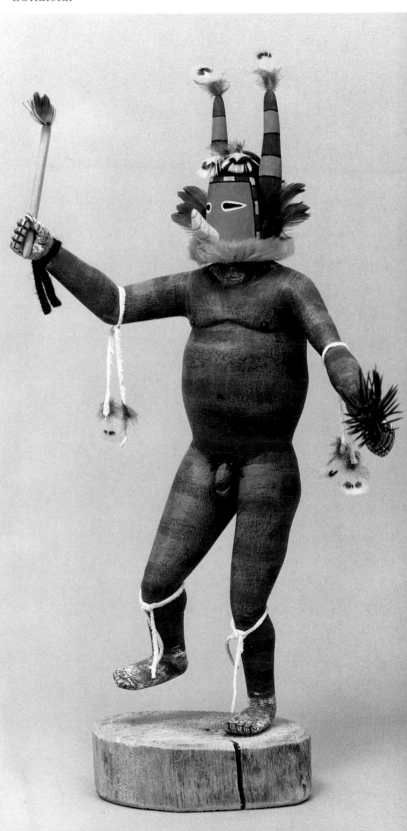

Paiyakyamu. An old Tewa clown figure by Tom Collateta.

clown, but a collection of Hano clowns carved in a variety of poses is very attractive. The same can be accomplished with the common Mudhead. The Wright/Bahnimptewa book provides the reader with illustrations of five other clowns.

Kaisale by Ernest Chapella and Hano Clown by Clarence Cleveland. Cleveland, a Navajo artist has lived in Shongopavy with his Hopi wife for 15 years.

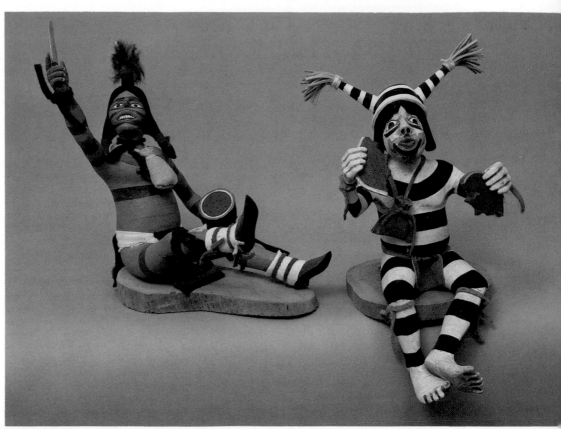

Three Hano Clowns by Neil David, Sr.

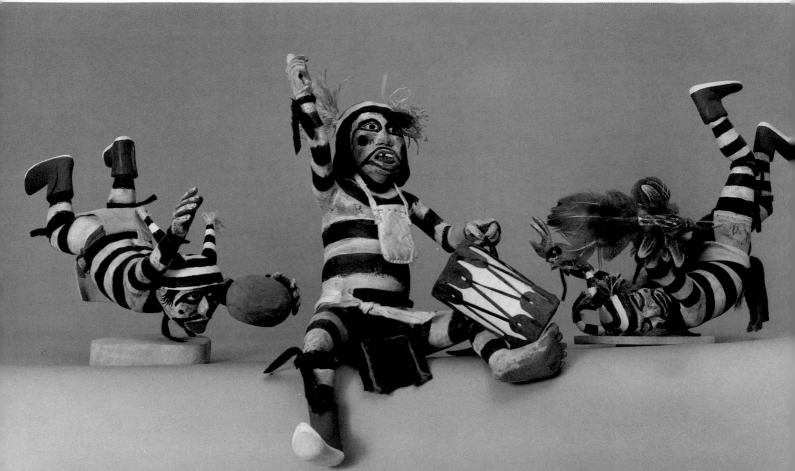

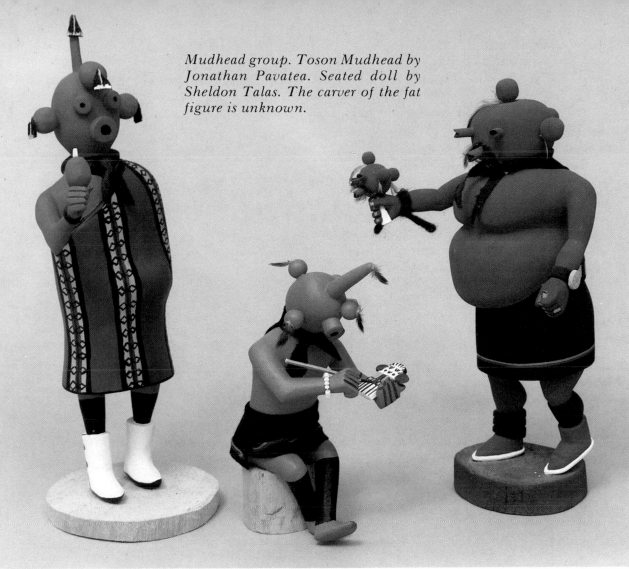

Mudhead group. Toson Mudhead by Jonathan Pavatea. Seated doll by Sheldon Talas. The carver of the fat figure is unknown.

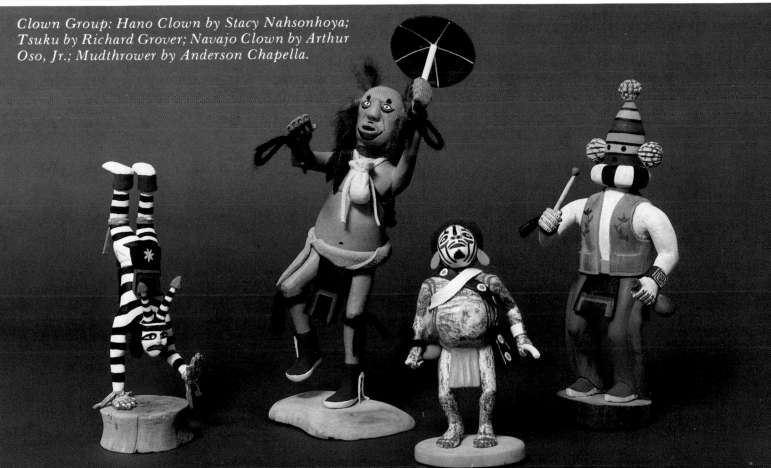

Clown Group: Hano Clown by Stacy Nahsonhoya; Tsuku by Richard Grover; Navajo Clown by Arthur Oso, Jr.; Mudthrower by Anderson Chapella.

The same volume illustrates another area for collectors—the Wawarus or runners. These are so named for the chase they give to hapless spectators at a dance and to whom they administer punishment. Illustrated in the book are the Crazy Rattle, the Greasy Kachina, the Stripper, Hair Hungry, Throwing Stick Man, Mud Kachina, Globe Mallow, Yellow Fox, Chipmunk, Red Skirt, Dragonfly, Cricket, Kokopeli Mana, Prairie Falcon, Chili Pepper, Dung Feeding, Worm Removing Girl, and Squash. There exist others: Pig, Grasshopper, Sandbag, et al, not portrayed in the book.

Pigs by Benson Seeni. Male and female figures.

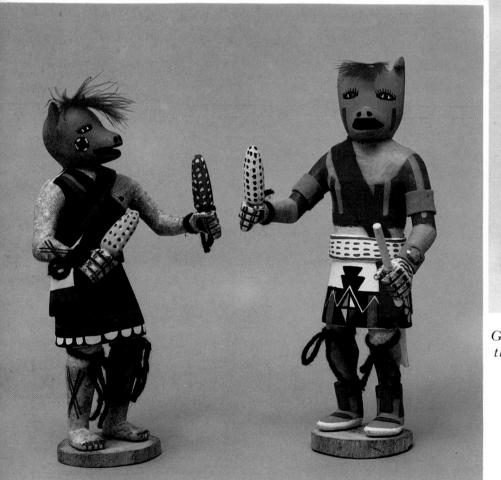

Greasy by Ronnie Calnimptewa. One of the many "runner" figures.

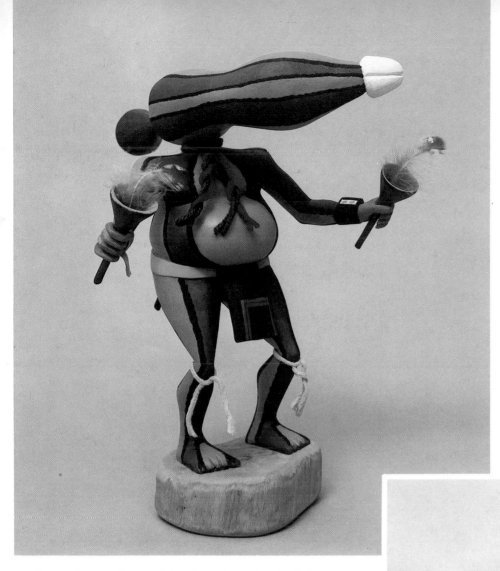

Squash or Pumpkin by Ronnie Calnimptewa. Another "Runner."

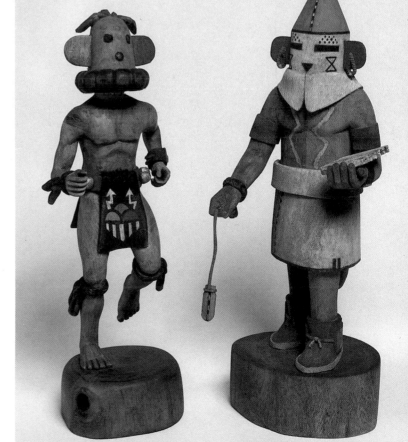

Chili Pepper (a "Runner") by Malcolm Fred and Heart of the Sky by Glenn Fred. Courtesy Adobe Gallery.

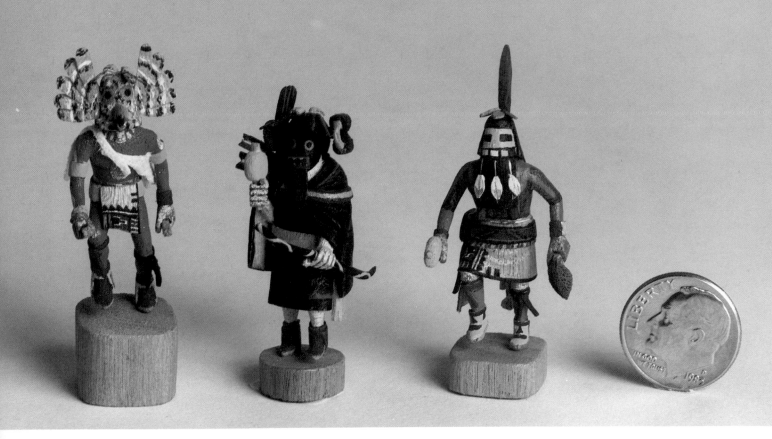

Miniatures by Duane Tawahongva, Owl, Hé-é-e and Longhair. Retail price of each is $600. Courtesy Adobe Gallery.

Collection of Miniatures.

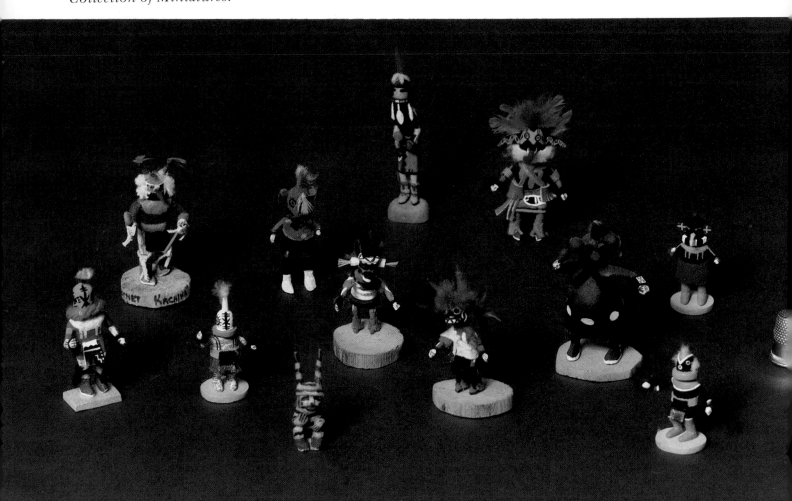

Other good collections can be assembled. Birds, animals, ogres, and Kachinas borrowed from the Zuni are all choices. There are collections of miniature dolls, up to three inches, or a collection can be devised strictly by size, usually to fit a shelf. Usually, these bookshelf dolls are between six and nine inches in height. Collecting large dolls, i.e., 25 inches and up, would be difficult. Few are made and even fewer are saleable. It may be desirable to collect Manfred Susunkewa's beautiful imitations of old-style dolls. Or Kachina doll sets, two or more dolls on one base, may appeal. A child's room can be decorated with a variety of flat Kachina dolls given to Hopi infants; or there are Hopi dance rattles with Kachina faces to collect. The cradle doll or Puchtihu by the way, stylistically has remained unchanged since the 19th century.

Miniatures by Bruce and Priscilla Augah.

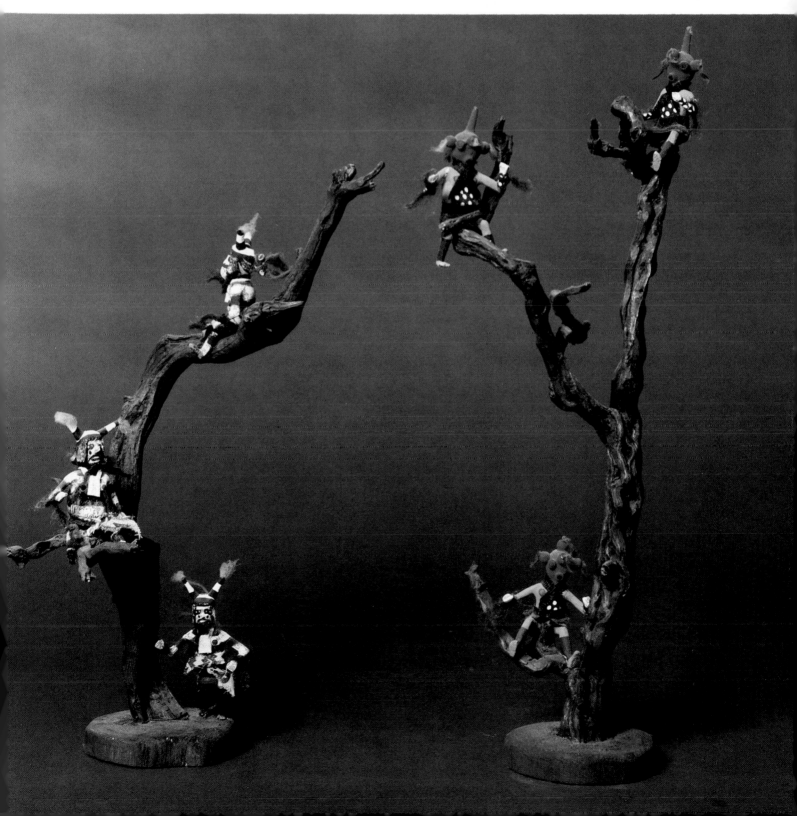

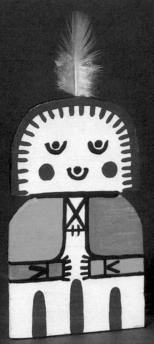
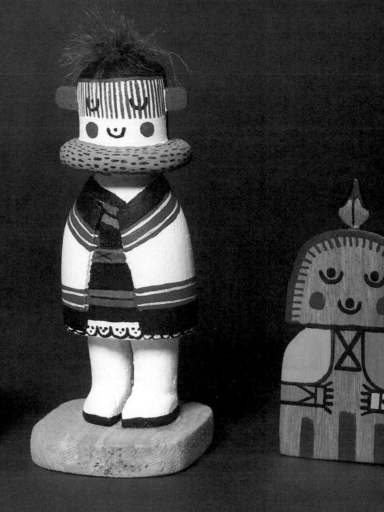

Three cradle dolls.

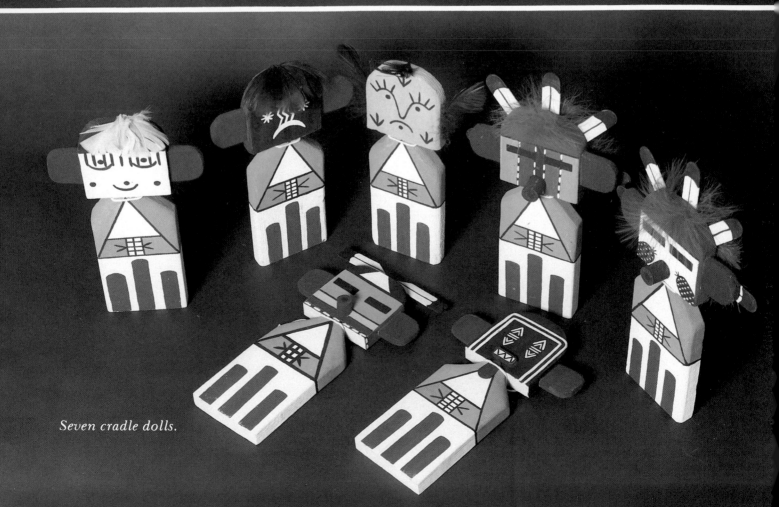

Seven cradle dolls.

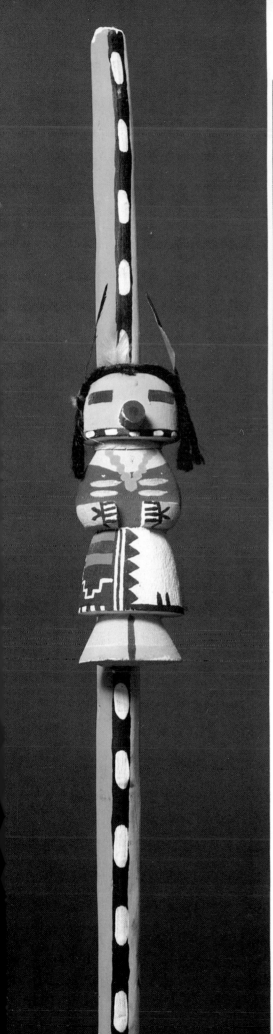

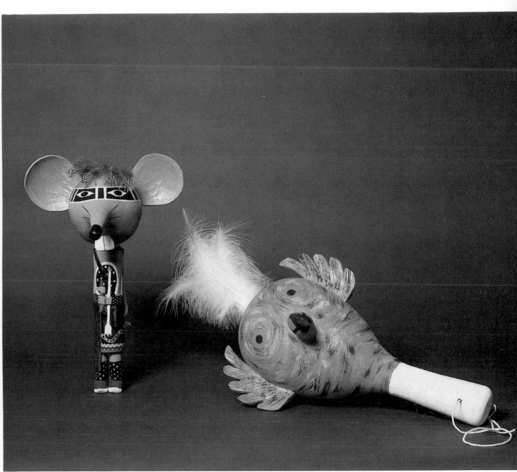

Mouse Rattle by David Washington and Owl Rattle by Manuel Hoyungowa

Hopi dance wand with doll.

The white collector, being what he is, may also insist on collecting dolls which most Hopi carvers will not make. The Cumulus Cloud is the prime example. (Clouds are regarded as manifestations of the recently deceased who remain eight days after death, produce a farewell rain, and depart for Mt. San Francisco Peaks.) Other figures avoided by most carvers are the Snake Dancers, Serpent (Creation), Somaikoli, Eototo, Aholi, Masau'u, and dolls made with removable masks.

Yaponchas, male and female. WindGod or Dust Devil by Tom Collateta. This is a rare impersonation of a troublesome figure.

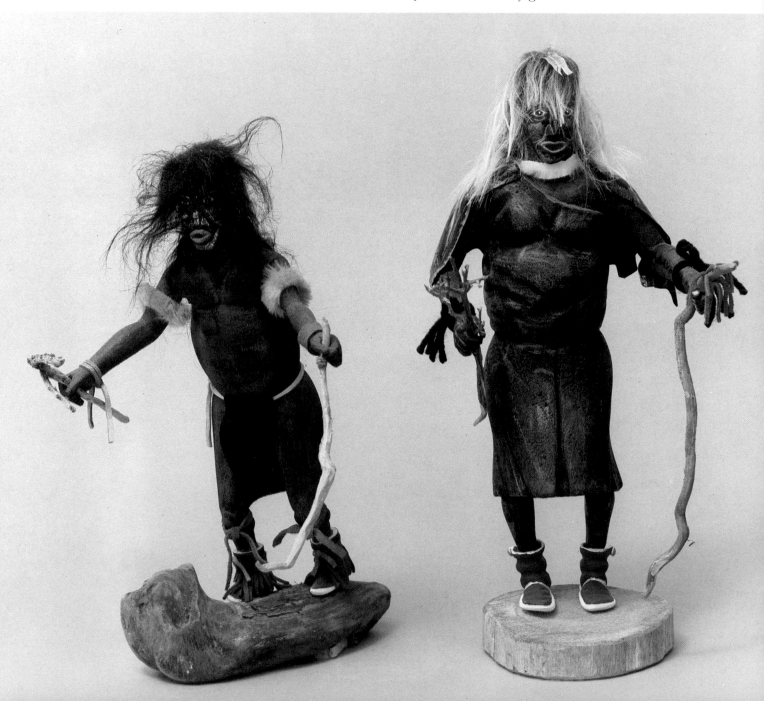

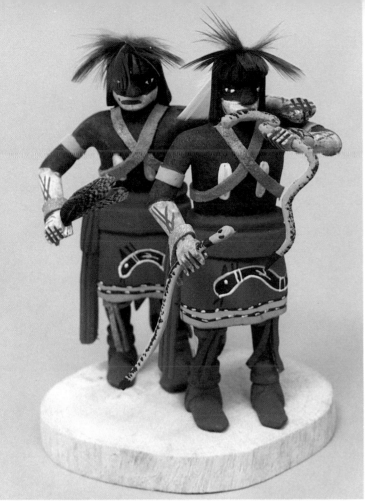

Snake Dancers by Murray Harvey. Few carvers will carve this set.

Snake. Also Serpent. An example of a doll few carvers would make.

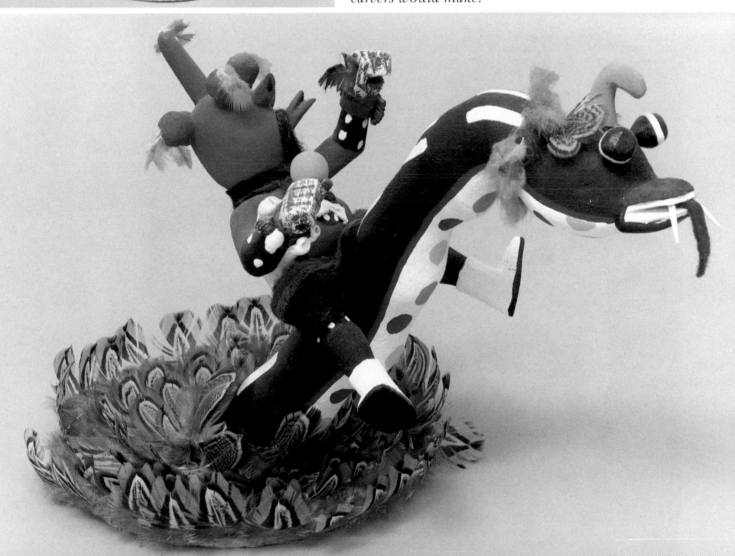

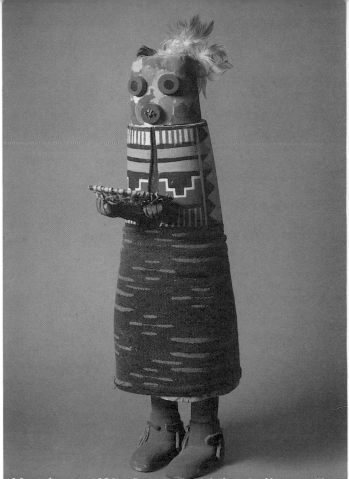

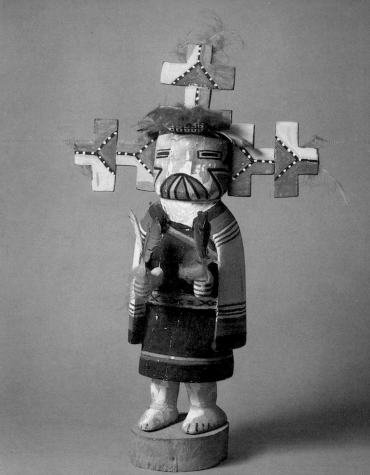

Masaúu c. 1930. Courtesy Adobe Gallery, Albuquerque.
Sai-astasana made by Jimmy Kewanwytewa c. 1940. Courtesy Frederick Dockstader.

Pahlik Mana c. 1930. Courtesy Adobe Gallery, Albuquerque.
Payik ála (three-horned Kachina) c. 1930. Courtesy Adobe Gallery, Albuquerque.

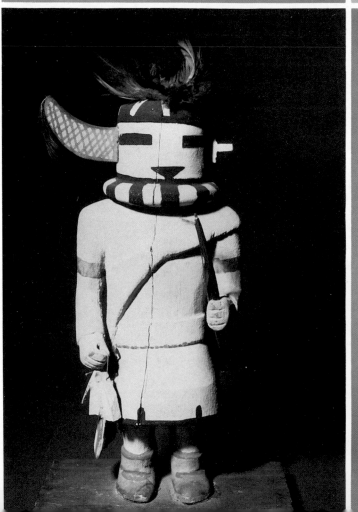

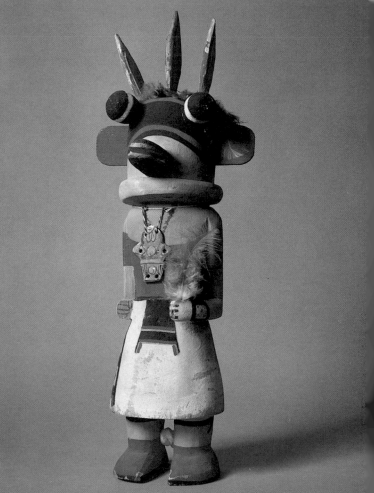

12. Antiquarian Kachina Dolls

What about antiquarian Kachina dolls—dolls made 40 years ago or before, that is, before the age of true commercial production began in earnest? This is a field of its own. Though this assertion will be disputed bitterly by collectors of dolls, these collections are largely built not on an aesthetic base but rather on their primitive, simplistic approach. The dolls were made relatively quickly and the precision and care employed today were simply not found then to any extent. The oldest Kachina figurine attributed to the 18th century was a flat object with an almost indistinguishable curve to suggest a head and some crude body paint. It was a doll which could also be a prayer stick. Nineteenth century dolls up to the Civil War generally maintained this crude, flat form. With the advent of the tourist, it appears that the guides and trading post operators began to suggest changes to the Hopi to make a more saleable figurine. The rounded, one-piece figure with feathers and straws attached appeared. Then arms closely clamped against the body and distinct, separated legs evolved. As mentioned earlier in the section on doll styles a photograph by Vroman made before 1902 shows the first modern "action" doll. Action dolls simply portray the body of the dancer as he dances. Thus, only bent legs indicated action in early dolls. After World War II, dolls with extended arms became common. Later there appeared the doll perched on one foot, the other raised in a dance step. The social dancer doll such as the White Buffalo is likely to have made its appearance at this time as a response to collector demand. Accompanying all this was a move away from the old earth paints to poster paints to latex and finally to acrylics. Commercial adhesives made their appearance after World War II and the use of sandpaper rather than sandstone became widespread. Today there are very few pre-1945 dolls on the market. Colors badly faded, feathers nearly eaten away, stiff and primitive, these are snatched up by museums and serious collectors whenever they appear. Well preserved, attractive dolls of the first decade

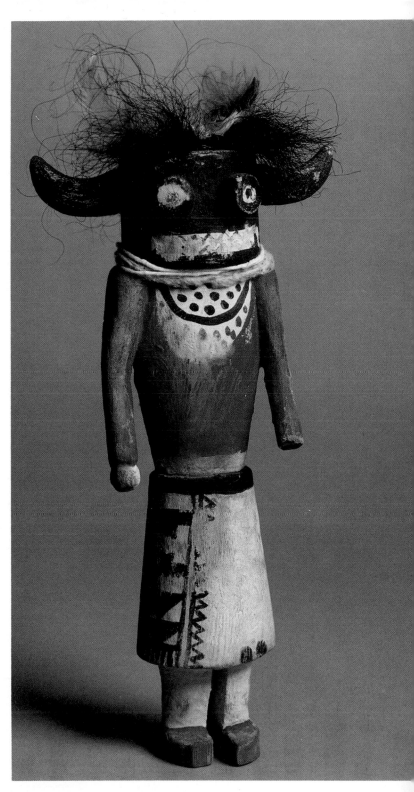

Counterfeit "old" Kachina doll made in Santa Fe c. 1980. Courtesy Adobe Gallery.

after the War are also in demand, and those of the first wave of action dolls in the second decade after the War. An unfortunately neglected account of the development of the art of the Kachina doll is Norma R. Litman's Master's Thesis. (See also Erickson, Jon T. "Kachinas, an Evolving Art Form," Phoenix, Heard Museum, 1977.) A word to the collector trying to use color to determine if a doll is authentic. Colors are *not* necessarily cast in concrete. A paragraph from Dockstader demonstrates this vividly.

"It was not possible to get a good turquoise color in early times... Today this has changed; turquoise-color commercial paints are readily available, as well as brilliant yellows and strong vibrant reds; the result is quite striking in comparison with older painted objects. Kachinas which were described as being painted in green in 1890 or 1900 are decorated in turquoise shades today; and one suspects the beauty of the newer shades has resulted in several Kachinas being changed from their original color to turquoise. In his (1903) series of color plates of Hopi Kachinas, Fewkes shows only five masks painted turquoise although a majority of those colored green in his book are usually painted turquoise today."[11] Incidentally, it is well to understand that styles and markings in costumes and masks of Kachina dolls do change over the years. Unfortunately, the change itself is not remembered by the Hopi, Barton Wright remarked to me. Thus, contemporary Hopis may tend to claim that an unusual detail in an old drawing or doll is wrong!

Longhair Uncle by Gary Hayeh.

Peeping Out Man by Ray Sumatzkuku; Zuni Shalako, carver unknown.

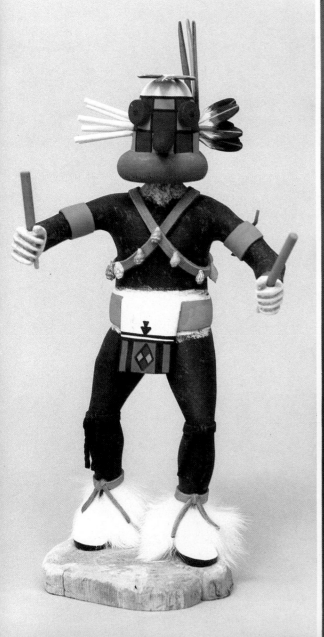

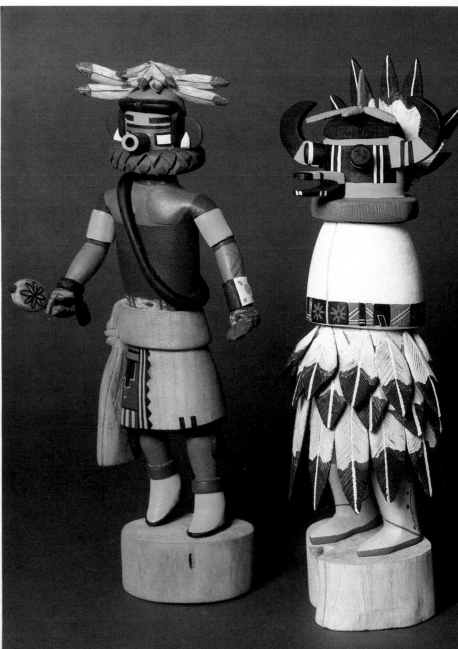

If you decide to collect old dolls, you must be fully aware that counterfeiting them is now big business and you had better know full well what you are doing!

One final word on collections. It is perfectly normal for collectors to upgrade their collections once they are a few years into collecting. The tendency for the beginner, unfamiliar with both techniques and prices, is to buy by price, that is, to buy a Kachina doll because it is inexpensive. With the passage of time, the collector's eye becomes much more critical and he is very uncomfortable with his early purchases. Since he can usually redeem his money, disposing of his earlier purchases to interested beginners, he subsequently makes fewer and more costly purchases.

Poli Taka by Leo Lacapa.

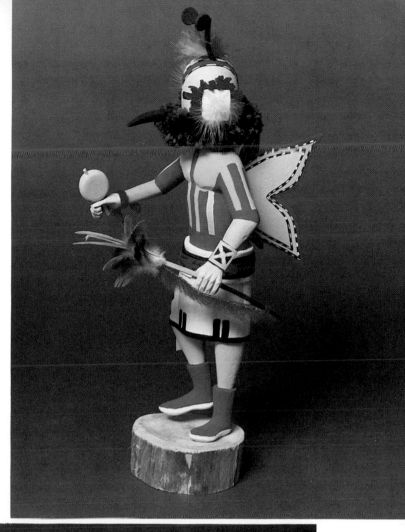

Powamu Mudhead by Jacob Fredericks and Warrior Mudhead by Leo Lecapa.

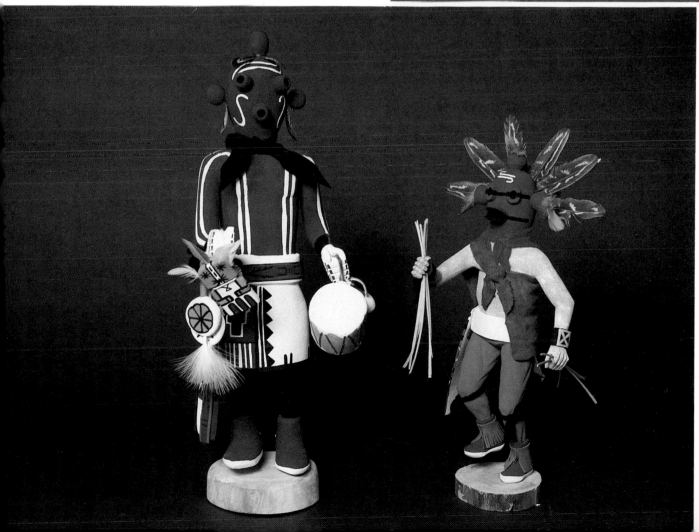

Ma alo by Layman Sakenima.

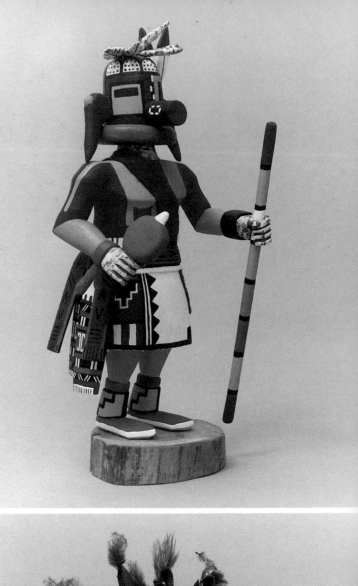

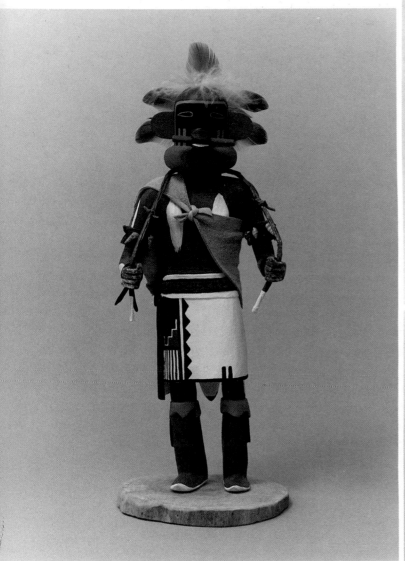

Piki Eater by Larry David.

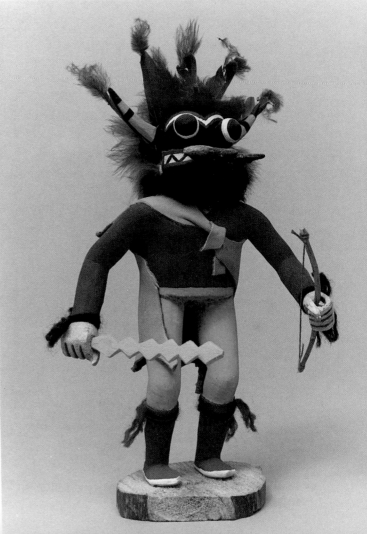

Fish. Carver unknown.

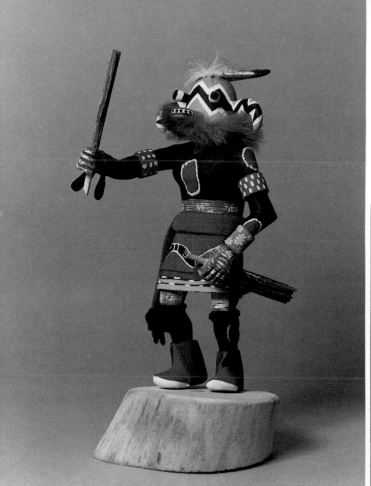

Second Mesa Whipper by Patrick Lanza.

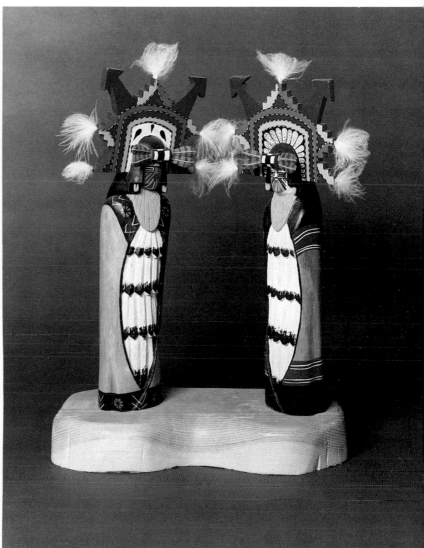

Hopi Shalako Pair by Darren Yowytewa. Courtesy Ruth Fifield, Santa Fe.

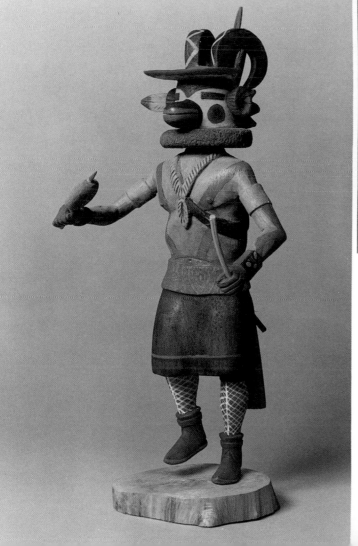

Mountain Sheep by Tino Youvella.

13. Some Collecting Problems

The collector of Kachina dolls has two problems not faced by collectors of another craft—first, the possibility of conflict with the government, and secondly, the prevalence on the market of imitation Kachina dolls made primarily by Navajos and sold by not too scrupulous dealers as authentic Hopi Kachina dolls.

Federal and state legislation has made it impossible for you legally to purchase a strictly faithful Hopi Kachina doll. Doll authenticity is established by garments, accessories carried, colors, and feathers. It is in the last category where the carver must deviate from the true. Kachina dancers carry feathers which may not legally be placed on a Kachina doll. (At one time nearly every Kachina doll carried eagle feathers.) The law is very strict in this regard. We are not merely speaking of the Endangered Species Act; we must also consider the Migratory Bird Treaty. The impact of these two pieces of legislation is powerful. No Kachina doll may be sold which carries any feathers except those from exotic birds such as parakeets, domestic fowl, or pheasant or quail. It is therefore illegal to apply even the feathers of a pest bird, i.e., grackle or crow. It is legal to shoot a mourning dove or mallard duck, eat it, use its feathers to make or sell pillows or fly-ties, but it is illegal to place them on Kachina dolls and sell them. The law also permits the use of feathers from the common sparrow, but the feathers of other types of sparrows which are forbidden are so similar that to be on the safe side, carvers will not use them.

The collector should look out for the feathers of two birds which are most frequently illegally applied by carvers—the mourning dove and the flicker. The latter is easily detectable by its red spine. The mourning dove is so similar to its domestic cousin, the pigeon, that long study is necessary to distinguish the two.

It will certainly occur to some of you to ask, "Why doesn't the Hopi tribe secure the same exemption from the feather laws the pillow-makers and the fly-tie manufacturers have?" The answer is simple and astonishing. The

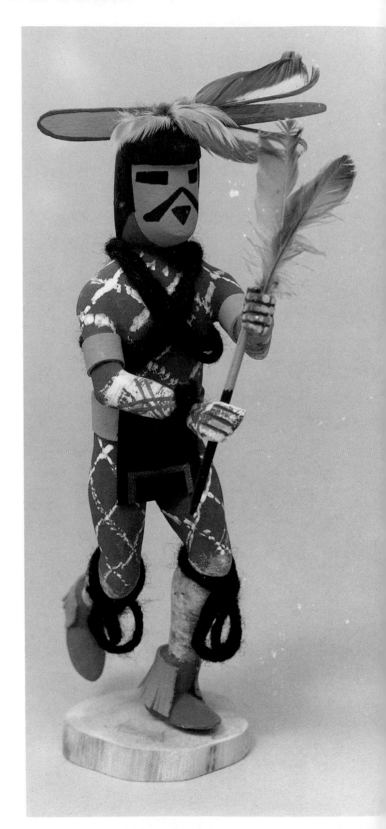

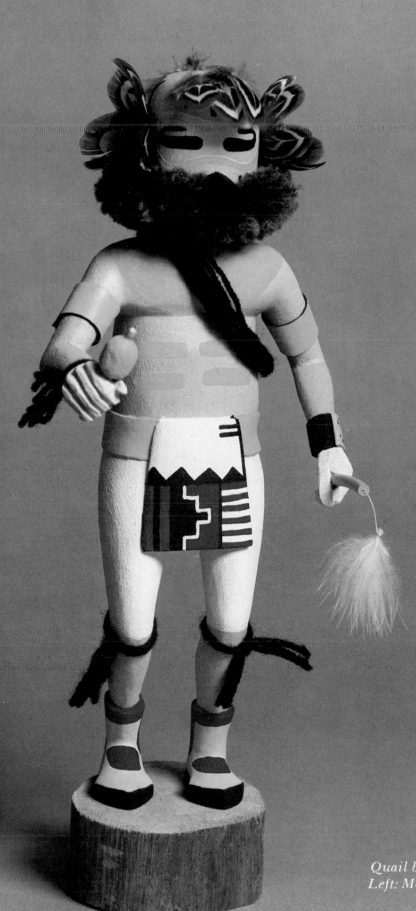

Hopi government does not want the exemption. It would simply prefer that the entire commercial trade in Kachina dolls would cease. It has actually rejected offers from the U.S. Congress to ease feather restrictions. To understand this attitude, you must understand Hopi society. It is well known that the small conservative faction opposes the sale of the dolls though some of its members participate in the trade. But that's not the answer! "Hopis are very jealous of each other!" This is a universal self-criticism by the Hopi. Hopi society is fragmented in several ways. In the society there are craftsmen who make their living by their crafts and there are non-craftsmen. The latter are usually U.S. government or tribal employees. There exists among the non-craftsmen no empathy for the craftsmen. And since the craftsmen are invariably non-political, they are never to be found in the tribal government which speaks for them. The advent of the artist Milland Lomakema to a high position in recent years does not seem to have brought any change at all in attitude. However, a style change which now demands that all feathers be carved may settle the problem.

Quail by Leo Lacapa.
Left: Mountain Sheep Herder by Elmer Joe Satala

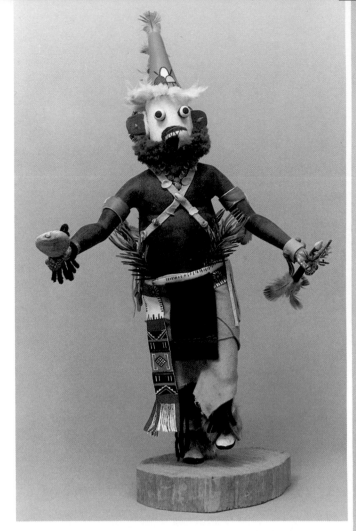

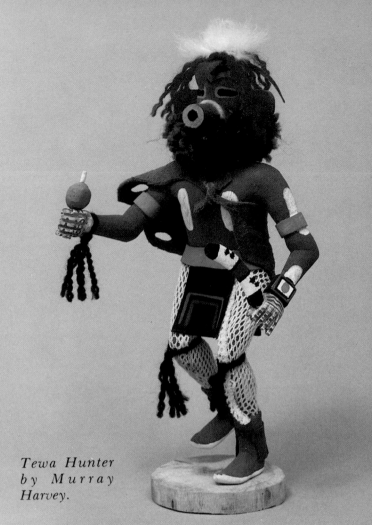

Tewa Hunter by Murray Harvey.

Tewa Ice-Man by Tom Collateta. A totally unknown figure to most Hopis.

Third Mesa Rainbow by Melbert Pongyesvia.

Tadpole by Frank Youyetewa. This is the old version following Fewkes.

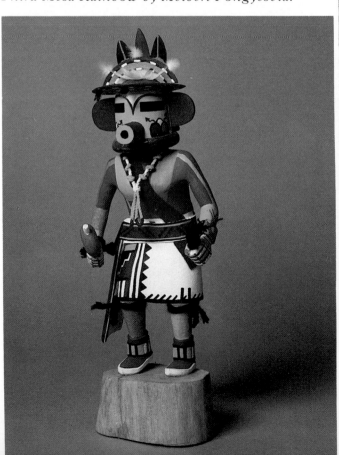

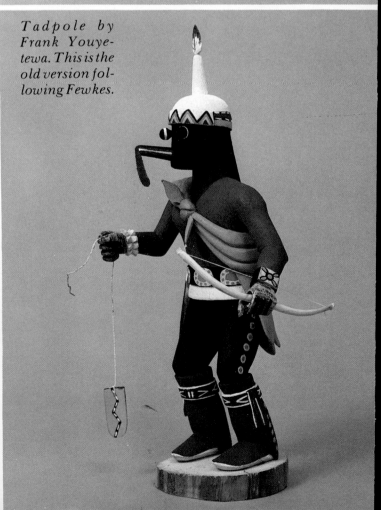

14. Navajo Kachinas

The Navajos, of course, have their own dolls—the *Yei Be Chei*. The Navajo have no history of affiliation with the Kachina cult. Popular belief has it that in 1973 a dealer in Gallup showed the then new Wright/Bahnimptewa book to Navajo craftsmen and suggested they copy the figures in the book. I am not certain of just what year I became conscious of the Navajo effort to enter a Hopi craft. Maybe the story is just a legend. The important thing to remember is that the Hopi Kachina doll is rooted in the Hopi religion and this religion is the irreplaceable essence of the Kachina doll from which comes its art. The shorthand for this "essence" as Henry Shelton puts it is simply the absolutely accurate transcribing of the sacred markings plus the accompanying reverence. This "essence" to the Hopi makes the innocuous wooden figure a Kachina doll. Carvers, not Hopi or Pueblo Indians, make dolls. They do not make Kachina dolls.

In recent years there has been a veritable flood of Navajo-made dolls which attempt to recreate the Hopi Kachinas. I would estimate that at any given moment there are many more Navajo copies than Hopi originals on the market. While some copies are amazingly correct, defying all but a very few to detect them, most Navajo products can be identified by even the beginner. Before we list the clues, let us define a Hopi as the Hopis themselves define one: a Hopi is a person whose mother is a Hopi or is an Indian who has been formally initiated in a kiva into the Hopi tribe. In reality, the definition of just who a Hopi is not that clear-cut. While a person whose mother is a Hopi definitely is a Hopi, regardless of who the father is, a person with a Hopi father and a non-Hopi mother is considered a half-Hopi with no clan, the clan being an essential in Hopi culture. A very famous "Hopi" jeweler was born a full non-Indian, was raised by Hopi parents, was sponsored by Hopi "aunts" and adopted into the religion. A noted Northwest artistic family is 100% white by birth but were adopted into a tribe and function as Indian artists. The question is a minefield which a number of years ago led to several resignations from the Indian Arts and Crafts Association.

Now the clues. First, the name of the carver. While there are some Anglo names among the Hopi, the collector is advised to be wary of dolls by Johnson, Brown, Smith, and Jones, surnames but rarely found in Hopi. The two tribes have in common surnames of Charlie, Ben, Fred, and Jim. Hopi names are generally distinctive and familiar to anyone accustomed to dealing with the tribe, particularly those ending in -tewa. Likewise, the Navajo tend to have distinctive

Fine Example of Navajo carved Doll by Lorraine Walker courtesy Palms Trading Co.

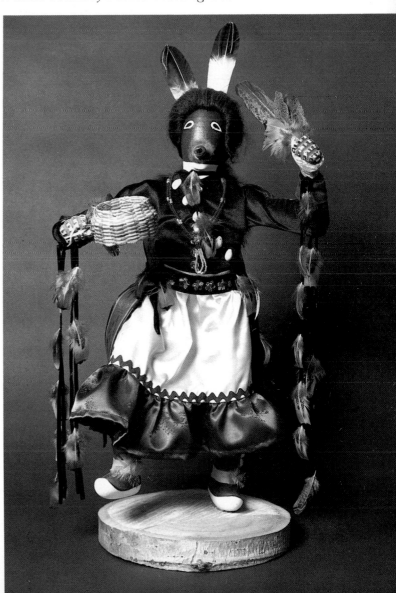

names as Goldtooth, Yellowhorse, Bicenti, Benally, Tsosie, Begay, and Yazzie. (A census of Hopi carvers is to be found in Appendix C.) Second, Navajo carvers have a great liking for excessive fur, feathers, and claws. Also, they tend to carve lean bodies in their own shapes. Navajos favor the eagle, white buffalo, clowns, white bear, and the Mudhead, though other figures are copied. Also, really huge dolls, over 25 inches, are rarely made by Hopi but are common among Navajos. Finally, the Navajo simply cannot capture precise, authentic colors, nor can he reproduce the body in the midst of a Hopi rhythm. Incidentally, when a Hopi is away from home for many years he tends to lose his eye for color and rhythm, so that a Hopi married into a distant tribe or otherwise in long exile tends to produce strange dolls. It is only fair to add that a number of collectors perfer non-Hopi dolls and collect the carvings of Johnny Burgess, the Cheyenne-Comanche, or Larry Hobbs, the Navajo.

The customer is well-advised to buy his dolls either from a shop which handles only authentic Hopi products or from one which handles both, but physically separates them and labels them as to what they are. On your request, a shop should give you an invoice attesting to the tribal origin of the doll which you have purchased. The problem of Navajo copies of Hopi Kachina dolls may disappear soon if the trend toward "all-wood", that is, all-carved dolls continues and grows among the Hopis as seems likely. Copyists of all tribes have not demonstrated the ability or the willingness to produce all-carved dolls to this date.

One last word! Unlike wholesalers, many retail dealers buy only what they personally like and invariably say that they cannot sell what they do not like. Since as a collector you may encounter a dealer whose tastes and yours differ, you may have to shop around. But if you find a dealer whose likes and dislikes are compatible with yours, cherish him!

Buy only what you like! Remember that only fifty years ago the Kachina doll was not art but rather was an ethnological specimen—a curio, to be frank. If we are to judge from the official Bureau of Indian Affairs publication "Pueblo Crafts" by Ruth Underhill the Bureau in 1944 did not even consider Kachina doll carving a craft, let alone an art! The very first mention in the literature of the Kachina doll was by an Army Surgeon Dr. P.G.S. Ten Broeck: "...some curious and rather horrible Aztec images made of wood or clay and decorated with paint or feathers..."

Another early Army man was even more vehement. Lieutenant John G. Bourke wrote "The Snake Dance of the Moquis of Arizona" in 1884. He states "...I bought several flat wooden gods or doll-babies. They are both. After doing duty as a god, the wooden image, upon giving signs of wear and tear, is handed over to the children to complete the work of destruction. These gods are nothing but coarse monstrosities, painted in high colors, generally green."[12] His contempt is stated again later on page 218: "In the principal room seven wooden idols in the stereotyped form of wood, painted in red, green, yellow, and black were attached to the middle of the smoke-blackened rafters."

But in the intervening years since these two Army men pronounced their dismal words, the Kachina doll has responded to western ideas of what is good art. Today the modern carver works much harder and more carefully than his grandfather. The doll he produces will, if anything, be more authentic in detail than the doll of a hundred years ago. Simple commercial pressure plus a good deal of innate creativity have impelled the Hopi carver to come up with true individualistic works of art which can grace your home and the homes of your friends. The art of Hopi Kachina doll carving has come into its own.

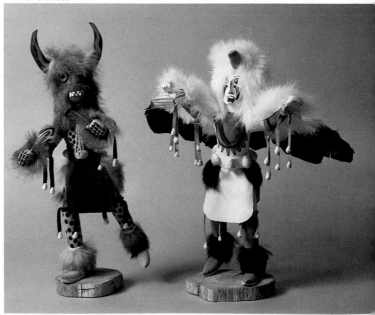

Two Navajo carved "Kachina" dolls courtesy Palms Trading Co.

15. Portfolio of Infrequently Portrayed Kachina Dolls

Carved by Elmer and Deloria Adams

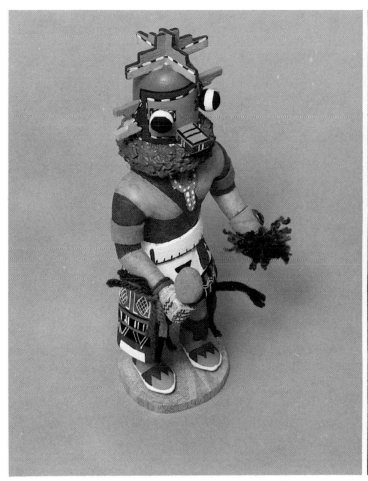

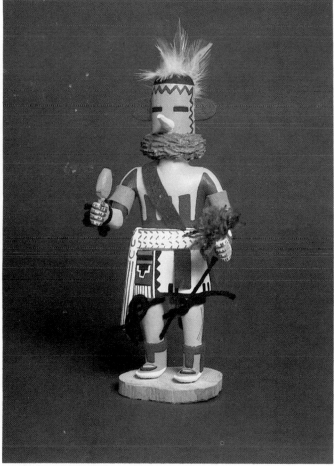

Cross-crown or Over-the-Cloud-Man or Four Corner Cloud by Elmer and Deloria Adams.

Eastern (Hopak) by Elmer and Deloria Adams. Refers to a branch of the ancient Hopi which did not settle with the main group but went East.

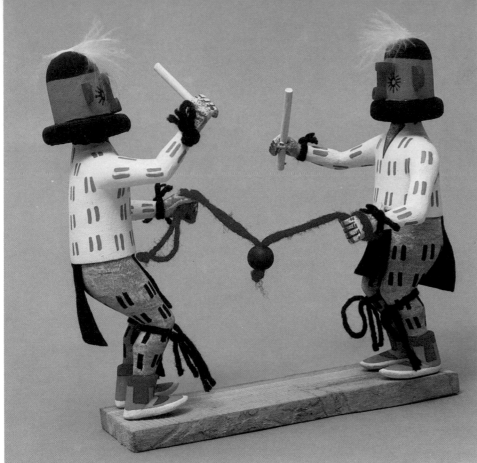

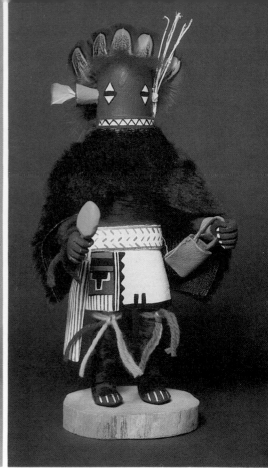

Ball-Players by Elmer and Deloria Adams. An old
Hopi sport.

Bear Clan by Elmer and Deloria Adams.

Albino Chakwaina, Colorful Heheya and Comanche Maid, and by Elmer and Deloria Adams.

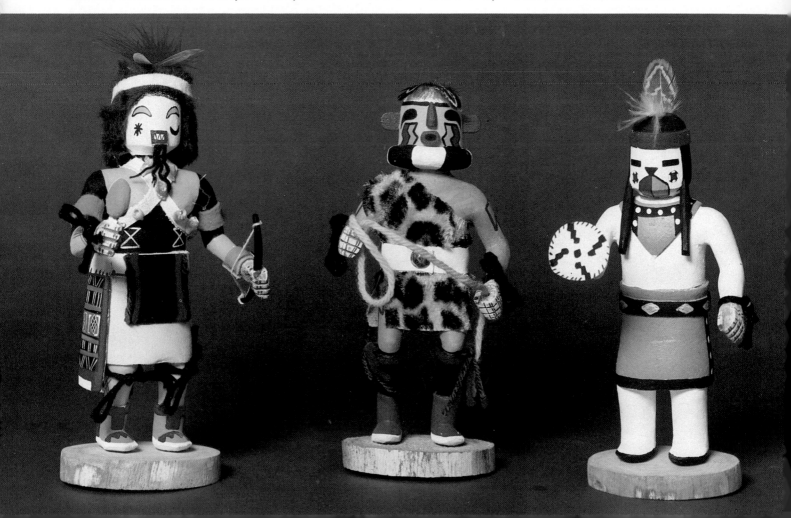

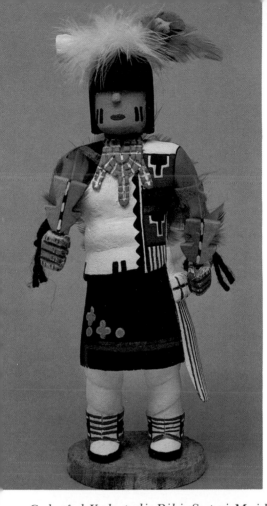

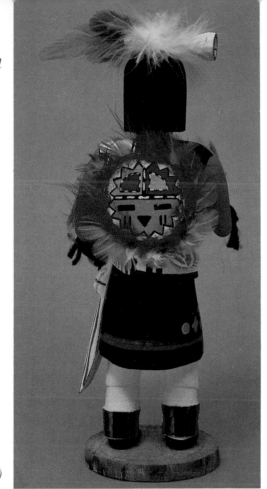

Buffalo Maid by Elmer and Deloria Adams.

(Another view)

Colorful Kokopeli, Piki, Supai Maid and Old Man by Elmer and Deloria Adams.

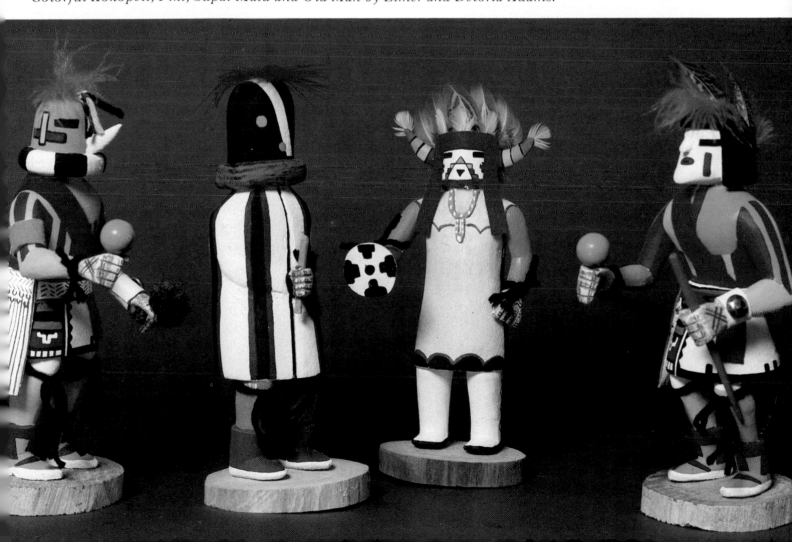

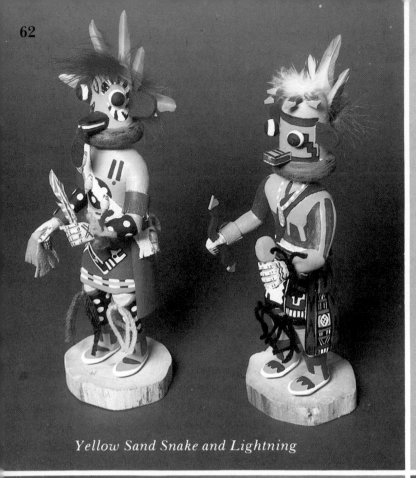

Yellow Sand Snake and Lightning

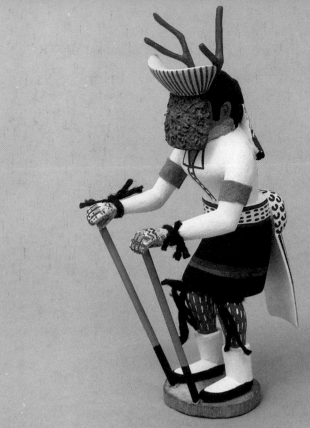

Social or Laguna Deer Dancer by Elmer and Deloria Adams.

Sio Hote by Elmer and Deloria Adams.

Star Whipper by Elmer and Deloria Adams.

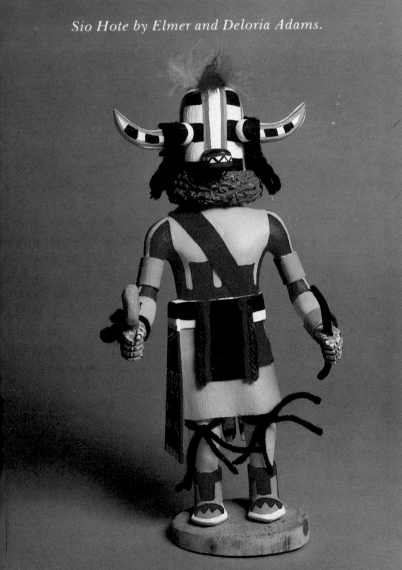

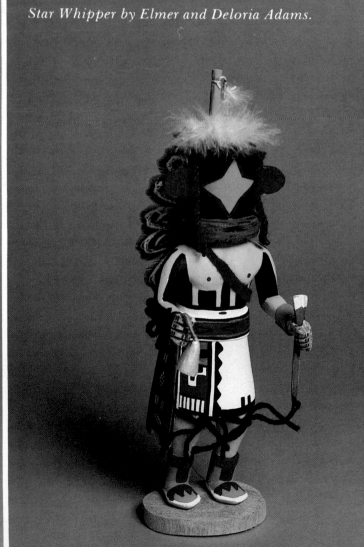

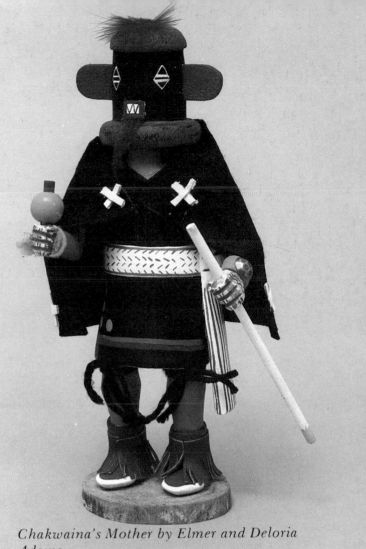

Chakwaina's Mother by Elmer and Deloria Adams.

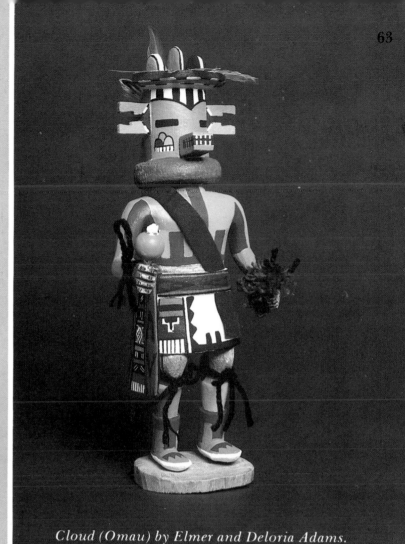

Cloud (Omau) by Elmer and Deloria Adams.

Social Bear and Pussywillow.

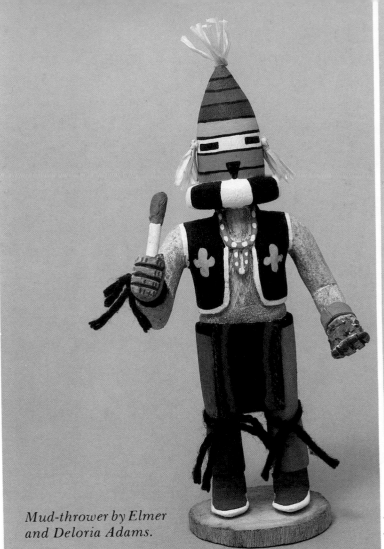

Mud-thrower by Elmer and Deloria Adams.

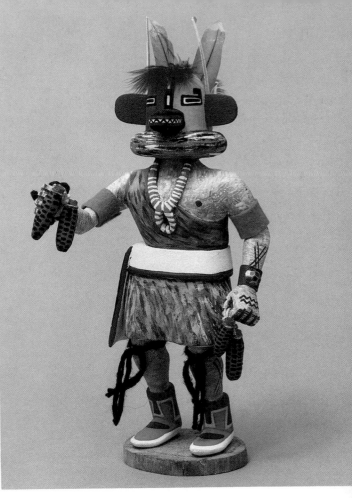

Roast Corn Throwing Boy by Elmer and Deloria Adams.

Supai Uncle, Blue Bear and Mashanta (Flower) by Elmer and Deloria Adams.

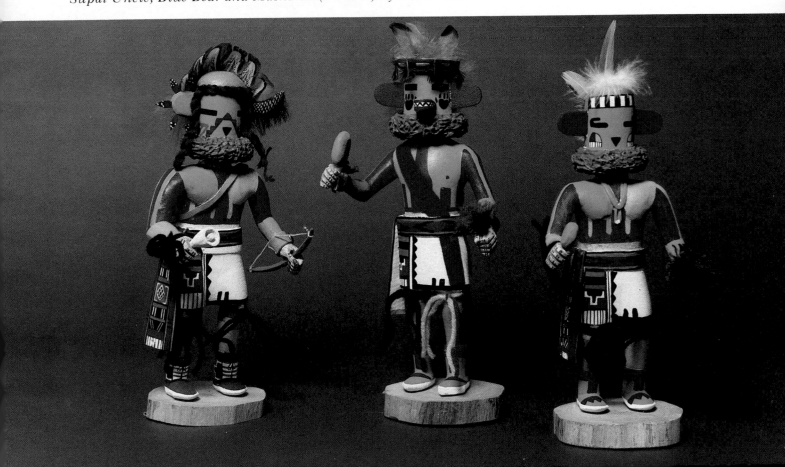

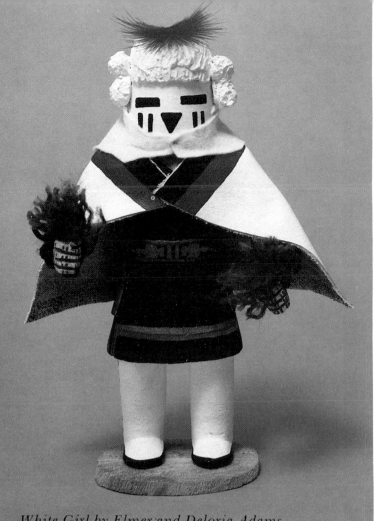

White Girl by Elmer and Deloria Adams.

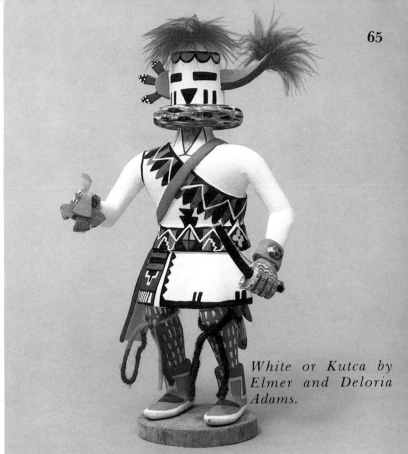

White or Kutca by Elmer and Deloria Adams.

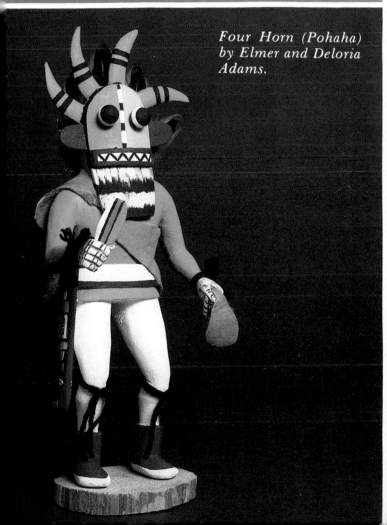

Four Horn (Pohaha) by Elmer and Deloria Adams.

Two Horn by Elmer and Deloria Adams.

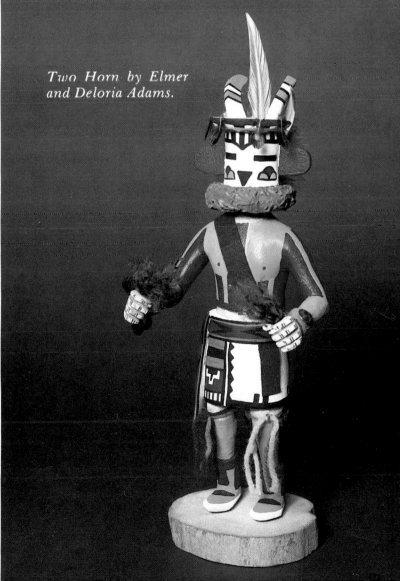

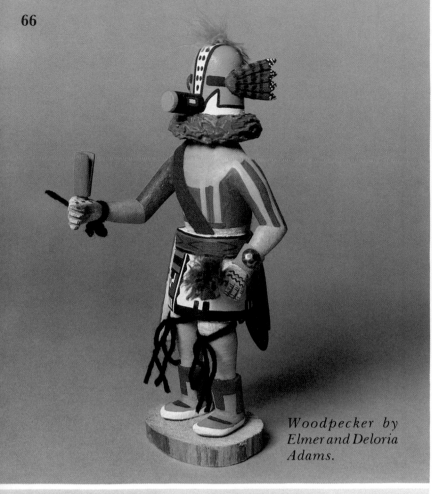

Woodpecker by Elmer and Deloria Adams.

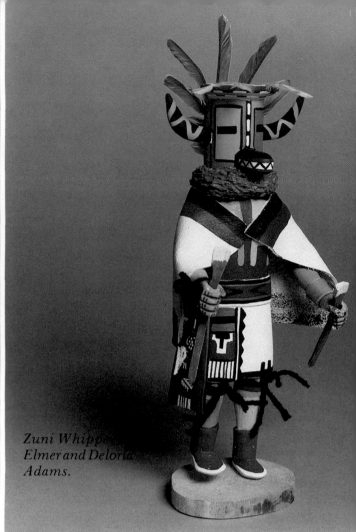

Zuni Whipp[...] Elmer and Deloria Adams.

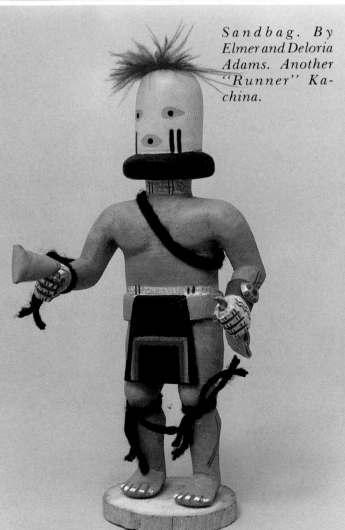

Sandbag. By Elmer and Deloria Adams. Another "Runner" Kachina.

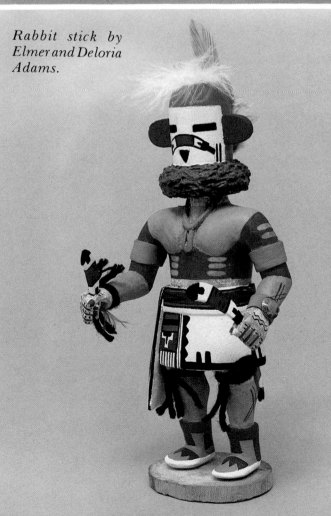

Rabbit stick by Elmer and Deloria Adams.

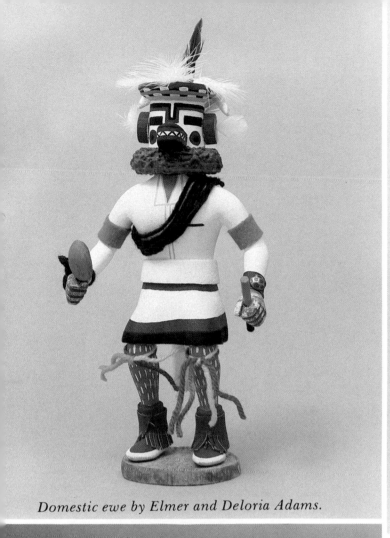

Domestic ewe by Elmer and Deloria Adams.

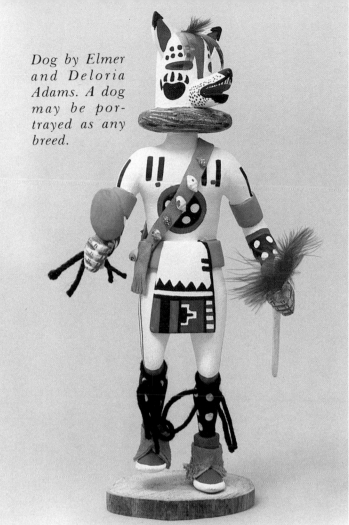

Dog by Elmer and Deloria Adams. A dog may be portrayed as any breed.

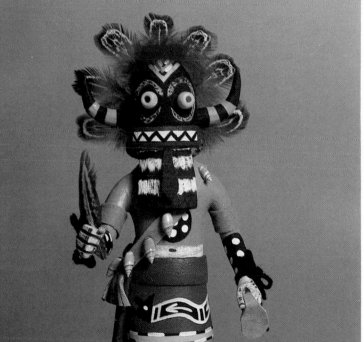

Sandsnake by Elmer and Deloria Adams.

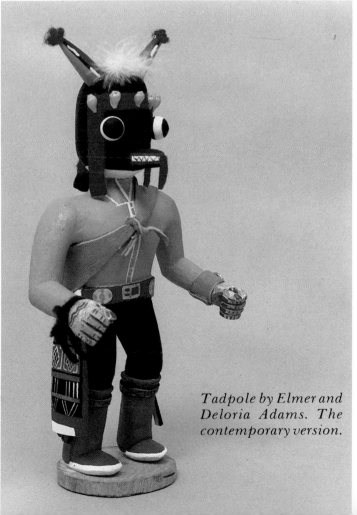

Tadpole by Elmer and Deloria Adams. The contemporary version.

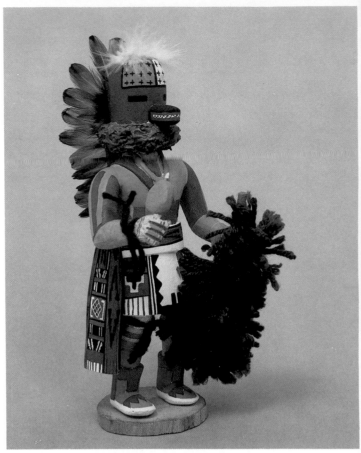

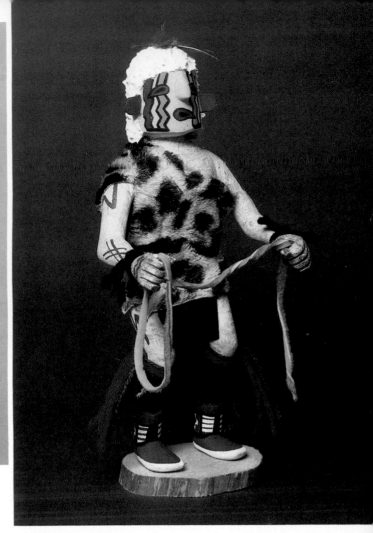

Coyote Clan by Elmer and Deloria Adams. A figure representing a particular clan rather than an animal.

Four Heheyas, yellow, blue, white and pink by Elmer and Deloria Adams.

Yellow Heheya Uncle by Elmer and Deloria Adams.

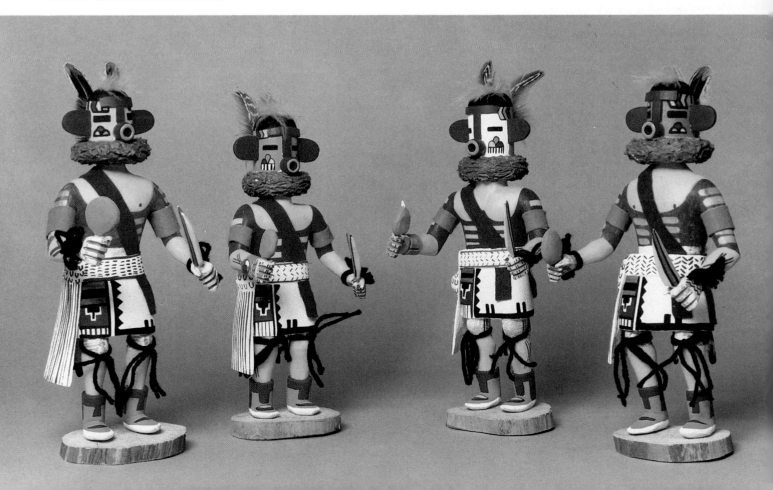

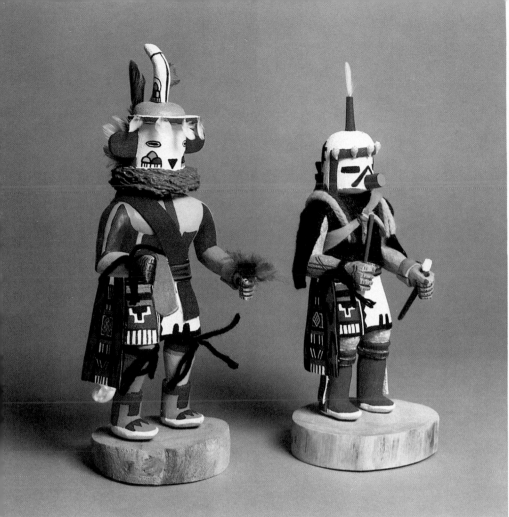

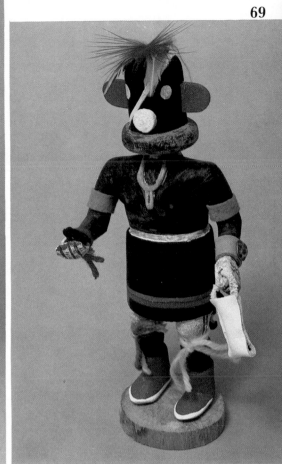

Coal by Elmer and Deloria Adams.

One Horn and Shalako (Inner Garment) by Elmer and Deloria Adams.

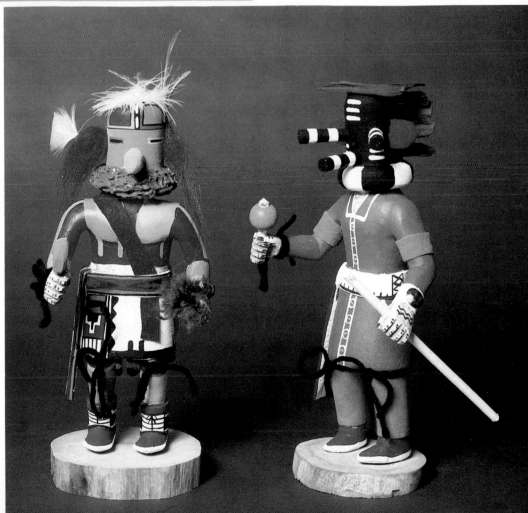

Zuni Navajo and Cedar Bark Head by Elmer and Deloria Adams.

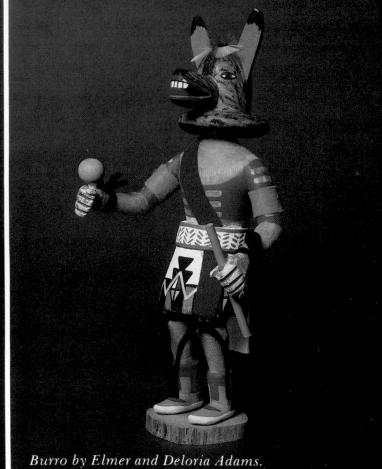

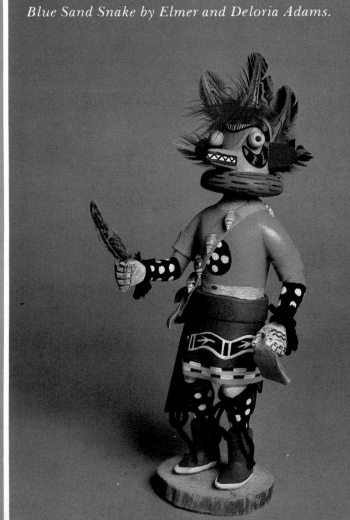

70

First Mesa Rainbow by Elmer and Deloria Adams.

Burro by Elmer and Deloria Adams.

Spiderwoman by Elmer and Deloria Adams.

Blue Sand Snake by Elmer and Deloria Adams.

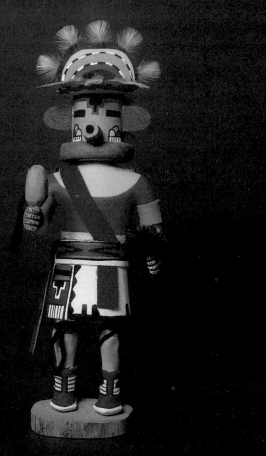

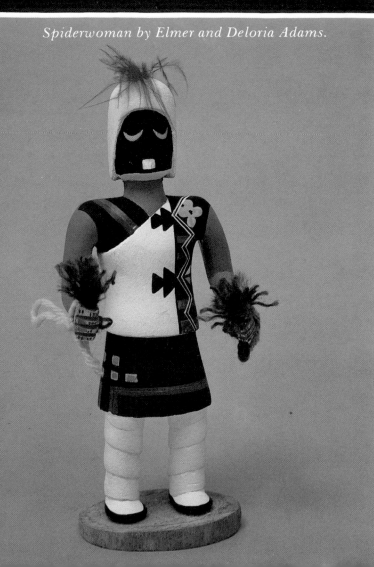

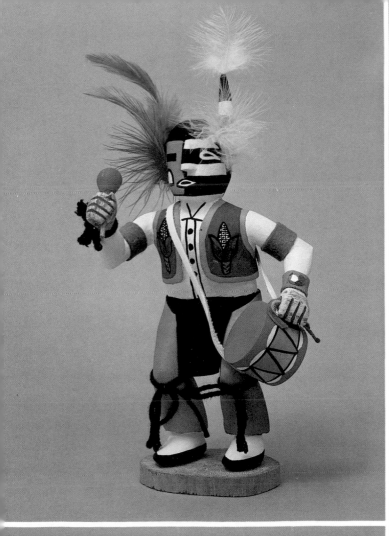

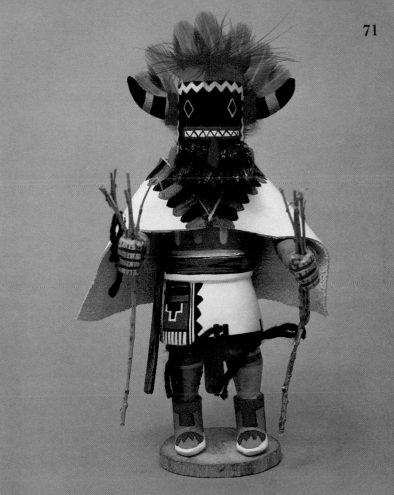

Pussywillow by Elmer and Deloria Adams.

Half-Clown by Elmer and Deloria Adams.
Kaisale Mana. The female counterpart of Kaisale the
Clown by Elmer and Deloria Adams.

Cactus Stick by Elmer and Deloria Adams. Money
and other valuables are placed among the spines and
women attempt to grab the "goodies."

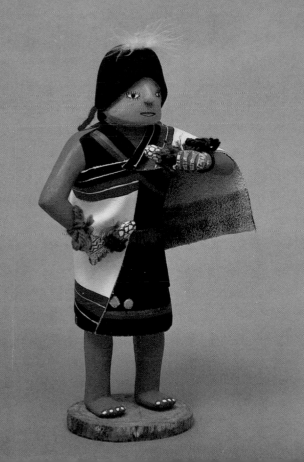

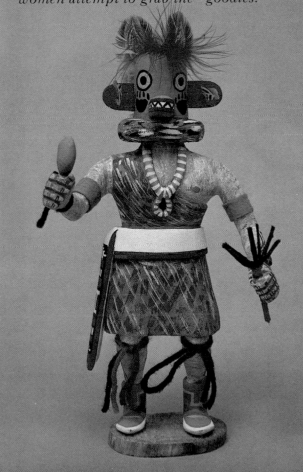

Corn Ruff Whipper by Elmer and Deloria Adams.

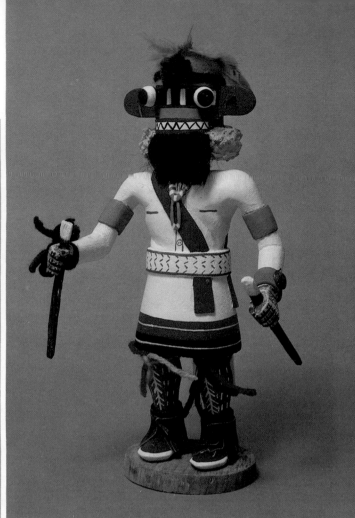

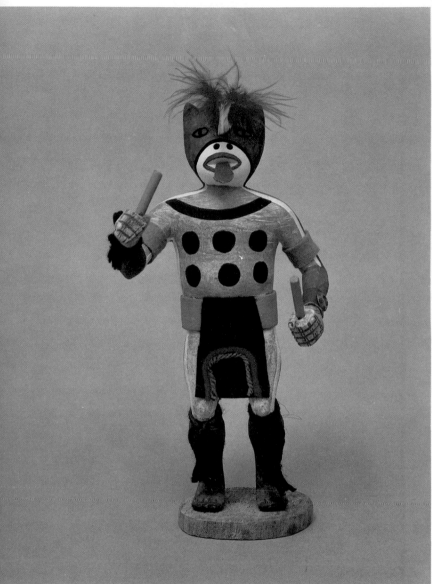

Frog by Elmer and Deloria Adams.

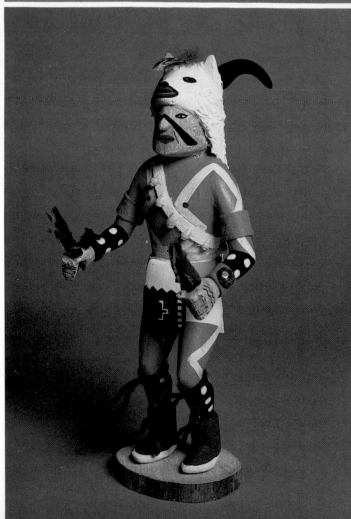

Goat by Elmer and Deloria Adams.

16. What's New? Natural Finish

When I began to write this book there were only hints of a style change in Kachina doll art brought about by collector demand. I refer to the advent of natural finish carving. This development is essentially the work of two carvers—Neil David, Sr. and Ronald Honyouti. About four years ago Neil David began to produce Kachina sculptures using the natural color of wood. (An early example may be found on page 30.) About the same time Ronald Honyouti of Hotavilla produced his first one-piece Kachina doll carvings in the same natural tones. One-piece carvings did exist before this time but were not produced with the skill of Honyouti. The history is vague here but apparently Honyouti decided to apply diluted acryllic paint. That is, the paints he used to indicate the usual Kachina motifs were almost pastel since the water introduced by the painter affected the sharpness of the acryllic colors. At about the same time Neil David began the now common practise of using a burning tool to depict such things as feathers. Burning tools are now found on all Mesas but the technique of the Hopi does not compare with that of Bill Veasey and his school of bird carvers.

Those areas of the doll which demanded no colors were finished in "natural"—that is, in wood tones. Clear stains in light or dark shades, according to the taste of the carver, were brushed over carefully sanded surfaces. Obviously this has meant that the wood used in the doll had to be consistent in coloration. It also demanded the wood be perfect—no wood filler countenanced.

This created a technical problem. Traditionally the body of the doll was carved armless. Provisions were made to join a separately carved arm at the shoulder using glue and pegs. The seam was carefully sanded down. The usual body paint applied later completely hid the join, giving the illusion of a one-piece doll. However,

if stain is applied to the body instead of paint, it is inevitable that there be an undesirable seam visible where the arm is joined to the shoulder. To overcome this—to continue the illusion of a one-piece doll—the upper arm is carved as one piece with the torso and the lower arm is joined at the carved arm band located near the elbow. The arm band, of course, hides the seam and makes the entire arm seem to be one piece with

(Pueblo) Baking bread in outside oven.

the body. In true one-piece carvings where the lower arm is flung out in some form of action it is necessary for the carver to begin with a really huge piece of cottonwood root. Carving appendages like that is the job of only a master carver.

This new style has demanded an inordinate amount of care by the carver. Care in selection of the wood, care in sanding and care in mixing the paints. Natural finish dolls require more time in production. The inevitable result is that natural finish dolls are considerably more expensive than traditional carvings.

Pueblo woman with her pottery.

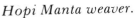
Hopi Manta weaver.

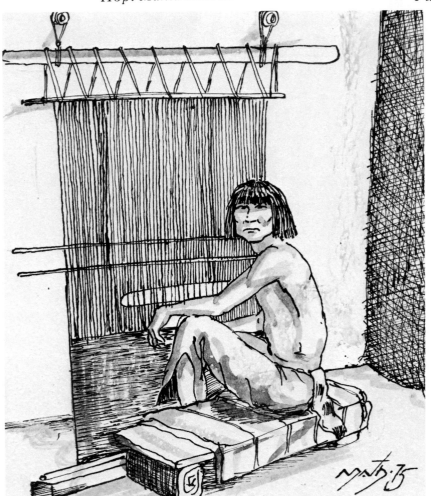

17. Repair Techniques
By Ailene Bromberg

Repair tasks fall into definite categories. The most common problem involves breakage of some part of the leg—especially the single limb on which the "action" doll perches. Next most frequent revolves around the illegal or perhaps the missing feathers. Then we should consider replacement of missing articles of dress—leather, fur, felt, yarn, shells, yucca, and straw. Working with lost carved accessories—rattles, knives, wooden feathers, and bows—is a bit more difficult. Finally, we should mention cleaning the doll—removing environmental pollution—inevitable even if you have the Kachina doll under glass.

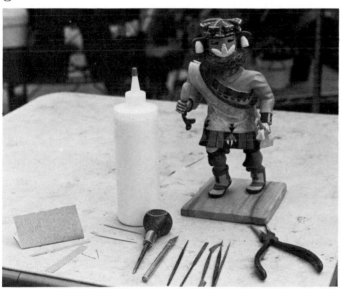

Legs
Ruptures and breakages of the leg of the action doll occur simply because of the undue strain on one foot bearing the load because the other has been elevated to indicate a dance step. First, examine the break carefully. Is it clean? Did it simply part at the natural join? Did it splinter in breaking? Can it really be repaired or is the rupture so severe that the doll must be turned over to a Hopi to carve and install a new leg? If the break is clean, apply Elmer's Glue and hold the two sections together until the glue takes hold. Place a temporary wedge under the elevated foot so that the broken leg does not bear

all the strain. Very often, the break is so severe that along with glue, a peg or nail reinforcement is necessary. With either an ice-pick or a fine-bit drill, make holes in opposite parts of the break. These holes must be exactly opposite each other in the join. Insert into these holes either a rounded tooth pick or a finishing nail with the head cut off. (Wooden pegs are preferable due to oxidization of nails.) The peg must fit snugly or should be glued in place. Other limbs than legs do break and the general approach used for the legs can be applied elsewhere on the doll.

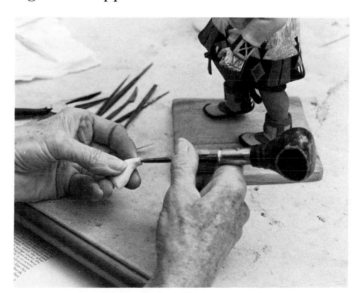

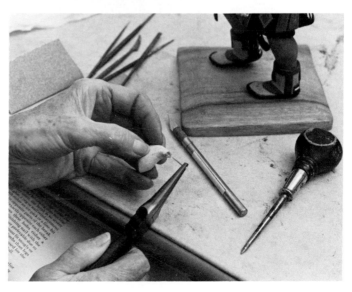

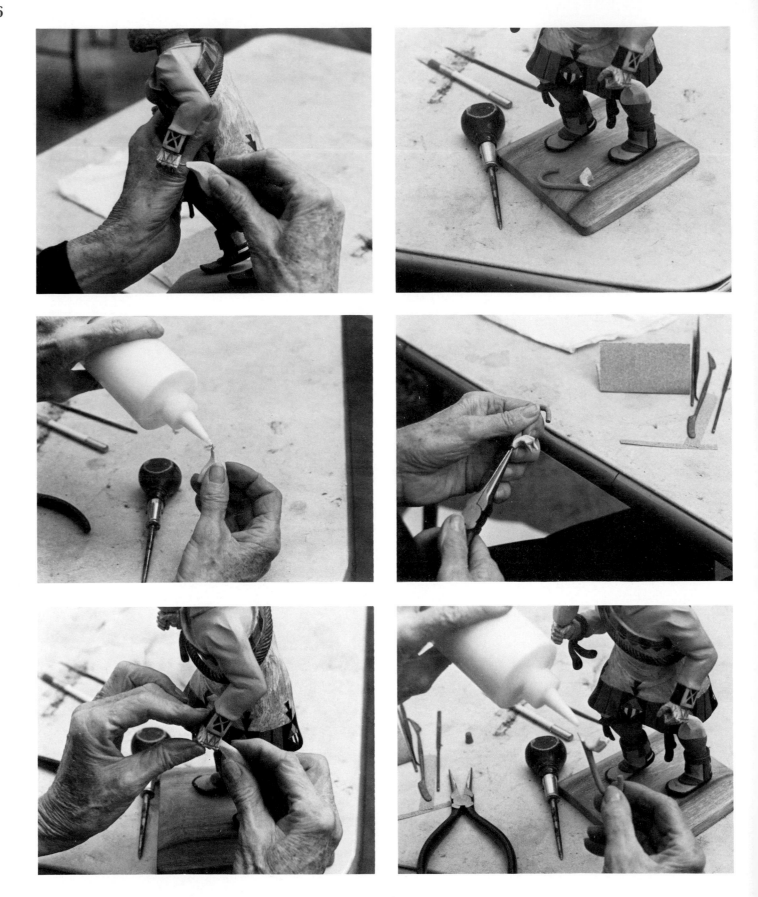

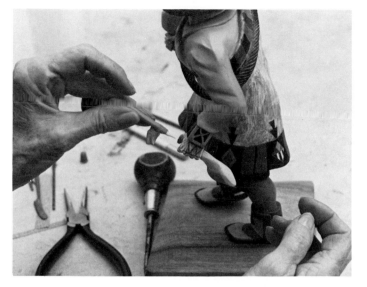

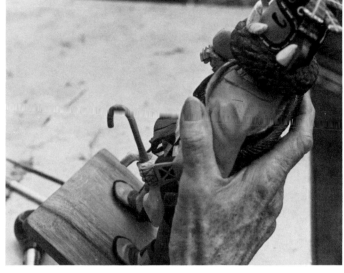

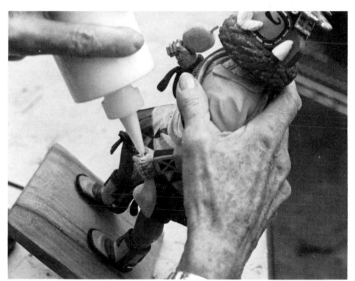

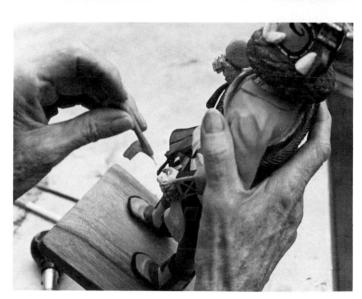

Painting

After the leg has been stabilized and the glue has set firmly, sand the join carefully to eliminate any indication that the join has been made. It may be necessary at times to use a wood filler to accomplish this end. After careful sanding, you are ready to paint. I cannot emphasize too strongly that correct paint is critical. All paint color on a Kachina doll has a meaning and you are not to alter it. Mix your acrylic paints until you have achieved the exact shade. To accomplish the usual simple jobs you should have on hand large tubes of white, black, and red oxide and small tubes of Grumbacher red, cadmium orange, yellow oxide, and Thalo green. The latter mixed with white produces many shades of the essential turquoise color. Optional colors are yellow and kelly green. Most dolls have a matte finish. If you have a doll with glossy paint, you may be required to make a trip to an artist's supply store. BLEND YOUR COLORS CAREFULLY. Paint is applied with several sizes of small flat brushes with sable or camel-hair. Fine lines will require a tiny spotting brush. Finally, do not be discouraged if the mend shows through the paint after your have applied it. Let it dry and then fine sand it once more. You may need three or even more paint applications.

Bases

Occasionally, you will find that the cotton-wood base on which the doll stands needs replacement. The artist in a hurry to complete his doll has used too small a stand and the doll tips easily. These stands are not hard to replace if you have a sharp, very thin knife. Use this—and

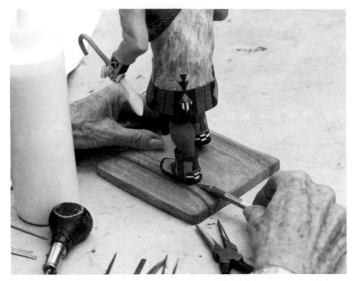

plenty of care and patience—to pry the doll's foot loose from the original stand. CAREFUL: the doll's foot is very easily broken. Once it is off, sand all residual glue and rough spots from the foot. Elmer's Glue is used to anchor the doll to the new base. If the glue appears not sufficiently strong to do the job, consider driving a nail through the stand and into the foot. Tap gently with a very light hammer. Use a nail set to complete the job if necessary.

Feathers

You may be called upon to replace illegal feathers or simply to replace a feather which has been lost or broken. Replacing the feather is much easier than removing it, for often the mounting of feathers by a good artist becomes an engineering feat. The only advice here is to study the technique over a long period and then when you are confident you have the puzzle in hand, proceed with the removal. In replacing feathers, one prime rule should be observed: *feathers have distinctive fronts and backs as well as lefts and rights and thus cannot be mixed.* You can work primarily with pheasant and pigeon feathers. For softer feathers, I prefer pheasant, and for stiff ones, pigeon. Cut and shape your feathers to meet the purpose you have in mind. For example, in applying a feather intended to lie flat on a doll's head, you should first snip off the stiff shaft. To fix a stiff feather to a doll, use an awl to make a hole in the doll and then glue the feather in place. In your stock, you also should have fluff from domestic fowls. These are attractive and are frequently lost.

Clothing

Most dolls of substantial quality today are totally carved—including feathers and every item of clothing. But some dolls, though, are dressed after completion—much as a child would dress her dolls. Moreover, in the case of the Kachina doll, the articles of wear are manufactured on the spot. Neckpieces are made of fur—rabbit fur is fine—or they are braided from green yarn. Leather and felt are used primarily for breech cloths and sashes, but here we are out of our element as sashes and breech cloths require precise, ceremonial painting by an artist. Simple leather belts, perhaps with small shells attached, which cross the chest can be replaced easily enough. Keep broom straws, yucca, and corn husks handy. Many dolls carry straw or yucca whips in their hands and these are frequently lost. Clowns often have corn husk "horn" tips and these deteriorate in time. Soak the husks you are to use until they are pliable and you will have little trouble.

Accessories

The carved accessory is another story. Here you run into difficulty. The Mudhead often loses his knobs or his rattle. These are easily carved and painted; occasionally a simple wooden bead of the correct size can be used. Carved knives, too, often drop off. Carve so the handle is round to fit in the hand. Paint the handle red and use a light gray paint for the blade. Replacing wooden feathers is not in your league unless you are a real craftsman. But, wood feathers, especially on the owl, very often break and this requires the procedures described early in this section under leg repairs. Broken bows are best repaired by joining the break under the hand holding the bow. Often, though, it is simply necessary to make a replacement bow.

Cleaning

Every collector will, from time to time, have to clean his doll. Air pollution and simple dust will eventually coat the figure. This is easier to handle than another form of "pollution"—sunlight—for the fading due to the sun's rays is permanent. Dust the doll carefully with a soft brush to remove surface dust. A modern doll prepared with acrylic paint can be cleaned with a slightly damp cloth. Old dolls with earth paints should never be cleaned with moisture. Only gentle dusting is recommended.

Practice makes perfect in doll repair. And remember that patience is your number one asset.

Appendix A
English Designations for Hopi Kachinas

The Hopi equivalent is not always a direct representation of the English. In many cases, as that of "three-nose", the English designation is only a nickname.

It is a mistake to assume that all Hopi Kachinas have an English name. Many Kachinas simply are named after the sound they utter in the dance—Hilili, Hututu, Ahote, Ho'ote, Holi and Aholi. Some Kachinas have managed to have their Hopi names become the English designation—Qoqole, Kaletaka, A-ha, Saviki, Marao and especially Salako are examples.

It should be noted that not all Kachinas have been depicted in publications. The Bahnimptewa-Wright book gave us an enormous assist in this area but there is a real need today for an "Encyclopedia of Kachinas" with colored illustrations. But no encyclopedia can be comprehensive. Kachinas can arise out of a dream by one man who thereupon makes his mask, performs his dance and soon thereafter all is forgotten. A few other Kachinas have existence only in some one's imagination—I feel the White Cloud Clown is one—and are only ephemeral.

This list should not be taken as complete. No effort was made in that direction. Nor should it be understood that there is agreement across all Hopi on these terms

English Term	Hopi Name	Colton Page #	Bahnimp- tewa Page #	Page # this book for rare examples. *See also Index for full list in this book.*
Adjutant	Aholi	8	19	
Albino Chakwaina	Koicha Chakwaina			60
Angry	*A class. See note 1 below*			
Antelope	Chof	90	165	
Apache	Yoche	205	145	
Ashes	Qochaf	19	25	
Assassin Fly	Kokopelli	65	109	
Badger	Honan	89	115	
Badger Clan	Wuwuyoma		55	
Ball Player	Tatasumu			60
Barefoot	Katoch Angak'china	126	173	
Barter	Kokosori	9	20	
Bean	Muzrubi	188	140	
Bean Dance	Powamu	38	71	
Bear	Hon	87	114	
Bear Clan's Uncle	Ke towa bi sena	224		60
Bee	Momo	67	85	
Big Ears	Hololo	103	168	
Big Forehead	Wukoqala	201	144	
Big Head	Wukoqote	102	35	
Bison	Mosairu	93	95	
Black Buffalo	Mosairu			13
Black Ogre	Nataska	29	78	
Blowing Sand	Chiwap	167	132	
Blue Bear	Sakwa Honau			64
Blue Sandsnake	Sakwa tuwa tcua			70
Blue Corn Maid	Sakwap Mana	165	15	
Blue Whipper	Sakwa Hu		53	
Bluebird Snare	Choshohuwa	203	41	

English Term	Hopi Name	Colton Page #	Bahnimp-tewa Page #	Page # This Book
Bobcat	Tokoch	84	31	
Broadface	Wuyak-kuita	22	26	
Broadleaf Yucca Old Man	Samo'awutaka	176	136	
Buffalo	Mosairu	93	95	
Buffalo Maid	Mucais Mana			61
Butterfly	Poli k'china	119	105	
Butterfly Maid	Poli Mana			9
Butterfly Man	Poli Taka	119	105	
Cactus	Yung'a	220	146	
Cactus Stick	Urcicmu			71
Canyon Wren	Turposka	74	88	
Carrying Wood on Head	Hakto	153	130	
Cat	Mosa			9
Cedar Bark Head	Laputki			69
Chameleon	Mongya	69	110	
Chasing Star	Na-ngasohu	148	42	
Chicken	Kowako	82	94	
Chief	Wuwuyomo		55	
Chili Pepper	Tsil	182	182	
Chipmunk	Kona	56	227	
Cholla Cactus	Ushe	204	46	
Cicada	Mahu	263	155	
Clay Ball	Choqapolo	53	224	
Cloud Guard	Tangik'china	266	250	
Clown	A class. See note 2 below			
Coal	Owaq	248		59
Cockleburr	Pachok'china	149	126	
Cold Bringing Woman	Horo Mana	101	34	
Colorful Assassin Fly	Kuwan Kokopeli			61
Colorful Heheya	Kuwan Heheya	34		60
Colorful Kokopeli	Kuwan Kokopeli			61
Comanche	Tutumsi	112	119	
Comanche Maid	Tutumsi Mana			60
Comb Hair Upwards	Horo Mana	101	34	
Compassionate	Ongchoma	18	69	
Corn Dancer	A class. See note 3 below			
Corn Grinding Girl	Pahlik Mana	120	106	
Corn Ruff Whipper	Silakap Ncontaqa			72
Cougar	Tokoch	84	31	
Cow	Wakas	94	167	
Coyote Clan	Hopinyu			59
Crazy Rattle	Tuskiapaya	258	209	
Cricket	Susopa	64	230	
Cripple	Tuhavi	144	123	
Cross Crown	Naho-ile-chiwa-kopa-choki	200		59
Cross Leg	Huhuwa	125	40	
Cross Stick	Naho-ile-chiwa-kopa-choki	200		59
Crow	Angwusi		158	
Crow Bride	Angwushahai-i	13	23	
Crow Man	Angwusi		158	
Crow Mother	Angwusnasomitaka	12	66	
Cumulus Cloud	Tukwinong	97	246	
Cumulus Cloud Girl	Tukwinong mana	98	247	
Dawn	Talavai	168	38	
Death	Masau'u	123	254	
Death Girl	Masau'u mana	124	255	
Deathfly	Mastop	6	13	
Deer	Sowi-ing	91	166	

English Term	Hopi Name	Colton Page #	Bahnimp-tewa Page #	Page # This Book
Devilsclaw	Tumaoal	241	64	
Dishevelled	Tiwenu	229	149	
Dog	Poko	257		67
Dragonfly	Sivuftotovi	58	229	
Dress	Kwasa-itaka	111	39	
Drummer	Kuwantotim	244	204	
Duck	Pawik	75	163	
Dung Carrier	Kwitanonoa	183	234	
Eagle	Kwahu	71	87	
Early Morning	Talavai	178	38	
Earth God	Masau'u	124	254	
Eastern	Hopak			59
Esteban the Moor	Chakwaina	160	99	
Ewe, Domestic	Kanale wuhti			
Farmer	Heheya	34		68
Farmer's Wife	Piptu Wuhti	252	241	
Feather's Upright	Kahaila	145	185	
Field	Paski	227	148	
Fish	Pakiowik	223		52
Flower	Tsitoto	45	30	
Flower	Mashanta	194		64
Flowers in the Snow	Sikyachantaka	253	208	
Flute	Lenang	106	36	
Foot Slapper	Piokak	174	134	
Four Corner Cloud	Naho-ile-chiwa-kopo-choki	200		59
Four Horn	Pohaha	218		65
Fox	Letaiyo	261	154	
Fringe Mouth God	Tasap	249	151	
Frog	Paqua			72
Gambler	Sotungtaka		157	
Germ God	Ahola	2	9	
Germination	Ahulani	164	14	
Giant	Chaveyo	37	27	
Girl Chaser	Heheya Aumutaka	36	83	
Globe Mallow	Kopon	54	225	
Glutton	Koyala	60	239	
Goat	Kapiri			72
God of the Sky	Sotuqnang-u	D1		41
Going Home	Hemis	132	214	
Grandmother	Powamu So-aum	39	72	
Greasy	Wik'china	49	220	
Great Horned Owl	Mongwa Wuhti	79	91	
Green Faced Whipper	Tungwup Ta-amu	15	24	
Guts in the Mouth	Sikyachantaka	253	208	
Haircutter	Hemsona	51	222	
Half Clown	Nah-took-vook eh			71
Hand	Sivu-i-quil taka	114	121	
Hano Cactus	Ushe	204	46	
Hano Clown	Koshare or Koyala	60	239	
Hano Clown	Paiyakyamu			37
Harvester	Huuh'tuh	240	203	
Harvest Girl	Pachavuin Mana	23	58	
Havasupai	Konin	143	184	
He Cuts Your Hair	Hemsona	51	222	
He Strips You	Novantsi-Tsiloaqa	50	221	
Headman	Hochani	113	120	
Hen	Kowako	82	94	
Hoe	Paski	227	148	

English Term	Hopi Name	Colton Page #	Bahnimptewa Page #	Page # This Book
Holding Entrails in Mouth	Sikyachantaka	253	208	
Home	Hemis	132	214	
Hornet	Tatangya	68	86	
Horse	Kawai-i	181	139	
Hummingbird	Tocha	76	89	
Humped Back Flute Player	Kokopeli	65	109	
Hunter	Kahaila	145	185	
Ice Man	Oeise			56
Imitator	Kwikwilyaka	107	37	
Jemez	Hemis	132	214	
Kachina Chief	Eototo	7	18	
Kachina Chief's Lieutenant	Aholi	8	19	
Kachina Mother	Hahai wuhti	44	60	
Laguna Corndancer's Uncle	Morzhivozi		157	
Left Handed	Suy-ang-e vif	95	32	
Lieutenant	Aholi	8	19	
Lightning	Talawipiki			62
Little River	Tunei-nili	134	177	
Lizard	Monongya	69	110	
Locust	Mahu	263	155	
Long-billed	Wupamo	41	29	
Long Hair	Angak'china	127	172	
Long Hair Kachina's Uncle	Morzhivozi			50
Longhorn	Wupa ala	96	116	
Mad	Owa-ngazrorro	198	45	
Making Thunder	Umtoinaqa	237	150	
Man With Reeds Tied On	Söhönasomtaka	189	62	
Meteor	Na-ngasohu	148	42	
Mocker	Kwikwilyaka	107	37	
Mockingbird	Yapa	77	90	
Monster Man	Awatovi Soyok Taka	26	76	
Monster Woman	Soyok Mana	27	74	
Moon	Hololo	103	168	
Mormon Tea	Hishab	193	142	
Morning	Talavai	168	38	
Motioning Woman	Horo Mana	101	34	
Mountain Lion	Toho	85	113	
Mountain Sheep	Pang	92		53
Mountain Sheep Herder	Lalai-aya			54
Mud	Chöqapölö	53	224	
Mud Ball Thrower	Tsukapelyu			39, 64
Mud Throwing	Chöqapölö	53	224	
Mudhead	Koyemsi	59	238	
Mudhead Ogre	Toson Koyemsi	32	81	
Mustard Green	I'she	265	156	
Navajo	Tasap	137	151	
Navajo Clown	Tasavu			39
Navajo Grandfather	Tasap Yeibichai	139	182	
Navajo Longhair	Tasap Angak'china	251	207	
Navajo Proud	Ninihiyo	245	205	
Navajo Rain God	Tunei-nili	134	177	
Navajo Talking God	Tasap Yeibichai	139	182	
Ogre	*A class. See note 4 below*			
Ogre Woman	Awatovi Soyok Wuhti	25	75	
Old Man	Wuwuyomo		55	
Old Man	Wutaka			61
One Horn	Kwanitaqa	D3		69
Over the Cloud Man	Naho-ile-chiwa-kopa-choki	200		59

English Term	Hopi Name	Colton Page #	Bahnimp- tewa Page #	Page # This Book
Owl, Great Horned	Mongwa	78	111	
Owl, Owl Woman	Mongwa Wuhti	79	91	
Owl, Screech	Hotsko	80	92	
Owl, Timber or Spruce	Salap Mongwa	81	93	
Paralyzed	Tuhavi	144	123	
Parrot	Kyash	190	193	
Peacock	Tawa Koyung	250	152	
Peeping Out Man	Na-uikuitaka	235	199	
Pig	Pijote			40
Planet	Na-ngasohu	148	42	
Plumed Serpent	Palolokong	233	198	
Pot Carrier Man	Sivu-i-quil taka	114	121	
Pour Water Woman	Hahai-i Wuhti	44	60	
Prairie Falcon	Kisa	72	232	
Prickly Pear	Navuk'china	109	117	
Priest Killer	Yo-we	255	50	
Proud	Kwivi	169	188	
Proud War God	Pöökang Kwivi	180	138	
Puma	Toho	85	113	
Pussywillow				63, 71
Quail	Kakashka			55
Rabbit Stick	Makto or Puutsko	222		66
Raccoon	Hochani	113	120	
Rainbow	Tanga'kah			70, 56
Ram	Pang	92		
Ram, Domestic	Kanalo			67
Piki	Wah uh uh			61
Piki Eater	Piki Sona			52
Ram Herder	Lalai-aya			54
Rasp	Muzribi	188	140	
Rattle	Aya	110	118	
Red Fox	Sikyataiyo	55	226	
Red Kilt	Palavikuna	57	228	
Red Skirt	Palavikuna	57	228	
Red-tail Hawk	Palakwayo	73	61	
Return	Soyal	1	7	
Rio Grande Clown	Tsuku	62	242	
River	Mona	236	200	
Roadrunner	Hospoa	207	103	
Roast Corn Throwing Boy	Tsekokakyenu			64
Robber Fly	Kokopeli	65	109	
Rock Crusher	Owa-ngazrozro	198	45	
Rock Eater	Owa-ngazrozro	198	45	
Rooster	Kowaku	82	94	
Runny Nose	Kau-a	234	178	
Runner	A Class. See note 5 below.			
Sand	Chiwap	167	132	
Sand Bag	Macmahola			66
Sand Snake	Tuwa-tcu-ah			67
Scavenger	Uhuhu			31
Scorpion	Puchkofmok	52	223	
Screech Owl	Hotsko	80	92	
Second Mesa Clown	Tsuku	62	242	
Shepherd	Lalai-aya			54
Shirt	Navan	171	191	
Shooting Star	Na-ngsohu	148	42	
Shooting Thunder	Umtoinaqa	237	150	
Silent	Talavai	168	38	

84

English Term	Hopi Name	Colton Page #	Bahnimptewa Page #	Page # This Book
Silent Warrior	Nakiachop	46	52	
Singer	Kuwantotim	244	204	
Skeleton	Masau'u	123	254	
Skeleton Girl	Masau'u Mana	124	255	
Skeleton Fetching	Maswik	115	252	
Skeleton Fetching Girl	Maswik Mana	116	253	
Small river	Tunei-nili	134	177	
Snake Dancer	Chusona			47
Snare	Huhuwa	125	40	
Snipe	Patszro	206	102	
Snow	Nuvak'china	99	33	
Snow Maiden	Nuvak'china Mana	100	213	
Solstice	Soyal	1	7	
Speckled Corn	Avachhoya	122	171	
Splendidly dressed	Kwivi	169	188	
Spruce Owl	Salap Mongwa	81	93	
Squash	Patung	225	236	
Squirrel	Laqan	83	112	
Star	Sohu	147	125	
Star Whipper	Sohu Hu			62
Stick	Ma'alo	130	176	52
Stone Eater	Owa-ngazrozro	198	45	
Stripper	Novantsi-Tsiloaqa	50	221	
Sun	Tawa	146	124	
Sun Turkey	Tawa Koyung	250	152	
Sunset Crater	Kana-a	142	97	
Supai	Konin	143	184	
Supai Uncle	Koo-ni			64
Supai Maiden	Konin Mana			61
Swaying Man	Nayaiyataka		201	
Sweet Cornmeal Mudhead	Toson Koyemsi	32	81	
Tadpole	Pakwabi	213		56, 61, 67
Terrific Power	Chowilawu	20	70	
Tewa Clown	Paiyakyamu			
Tewa Clown Maid	Kaisale Mana			
Tewa Hunter	Cipomeli			37
Three Horn	Payik'ala	168	133	71
Three Nose	Koroasta	173	101	56
Three Nose	Kwasa-itaka	111	39	
Thrower	Tsukapelyu			39, 64
Throwing Stick	Puchofmoktaka	52	223	
Thunder	Mona	236	200	
Timber Owl	Salap Mongwa	81	93	
Turkey	Koyona	208	104	
Turquoise Nose Plug Man	Chospos-yaka-hentaka	140	122	
Turtle	Kahaila	145	162	
Two Horn	Alosaka	D4		65
Velvet Shirt	Navan	171	191	
Warrior	Ewiro	202	63	
Warrior	Chakwaina	160	99	
Warrior Maiden	He'e e	21	57	
Warrior Maiden	Chakwaina Sho'adta	162	100	
Warrior Maiden	Söhönasomtaka	189	62	
Warrior Mudhead	Kipok Koyemsi			51
Wasp	Tatangaya	68	86	
Water Drinking Girl	Pahlik Mana	120	106	
Water Serpent	Palölökong	233	198	
Well Dressed	Kwivi	169	188	

English Term	Hopi Name	Colton Page #	Bahnimp-tewa Page #	Page # This Book
Whipper	Pachavu Hu	16	56	
Whipper's Uncle	Tungwup Ta-amu	15	24	
White Bear	Kocha Honau		114	
White Buffalo	Kocha Mosairu			29
White Chin	Tuma-uyi	141	183	
White Corn Girl	Angak'china Mana	128	174	
White Girl	Angak'china Mana	128	174	
White Girl	Kutca Mana			65
White Kachina	Kutca			65
White Ogre	Wiharu	31	80	
Wildcat	Tokoch	84	31	
Witch	Hilili	185	43	
Wolf	Kweo	86	164	
Wood Carrying	Hakto	153	130	
Woodpecker	Hopony	259		66
Worm Removing Girl	Sakwats Mana	184	235	
Yellow Corn Maid	Takursh Mana	129	175	
Yellow Fox	Sikyataiyo	55	226	
Yellow Heheya	Sikya Heheya			68
Yellow Sand Snake	Sikya tuwa tcua			
Yucca	Movitkuntaka	172	192	
Yucca Skirt or Shirt	Movitkuntaka	172	192	
Zuni Boy	Shulawitsi	151	128	
Zuni Butterfly	Poli Sio Hemia	246	206	
Zuni Corn	Sio Avachhoya	166	189	
Zuni Fire God	Shulawitsi	151	128	
Zuni Hemis Butterfly	Poli Sio Hemis	246	206	
Zuni Home Dancer	Sio Hemis	210	216	
Zuni IIo otc	Sio Ho ote			62
Zuni Maiden	Hoho Mana	156	217	
Zuni Navajo	Teuk	212		69
Zuni Rain Priest	Sai-asta-sana	154	131	
Zuni Rattlesnake	Situlili	211	47	
Zuni Sun God	Pautiwa	150	127	
Zuni Uncle (Home Dance)	Sio Hemis Ta-amu	157	98	
Zuni Warrior	Sipikne	152	129	
Zuni Whipper	Sio Hemis Hu			66

NOTES FOR APPENDIX A

[1]Angry Kachina: includes Homahtoi, Nakiachop, Owa-ngazrozro, Söhöna-som-taka, Toho, Wuyak-kuita.

[2]Clown and Humorous Figures: includes Choshuhuwa, Hó e, Huhuwa, Kaisale, Kowako, Koyala (Hano Clown), Koyemsi (Mudhead), Kwikwilyaka (Mocker), Piptu Wuhti, Piptuka, Qöqöle.

[3]Corn Dancer: includes beyond the conventional Corn Dancer found on page 201 of Bahnimptewa (Colton 238) Avachhoya, Harvester, Ka'e, Sio Avachhoya, Sotung-taka.

[4]Ogre: includes Atosle, Awatovi Soyok Taka, Awatovi Soyok Wuhti, Nataska, Soyok Mana, Soyok Wuhti, Tahaum Soyoko, Toson Koyemsi, Wiharu.

[5]Runners: includes Aya, Chöqapölö, Fox, Hemsona, Kisa, Kokopelli Mana, Kona, Kopon, Kwitanonoa, Novantsi-Tsiloaqa, Palavikuna, Patung, Puchkofmoktaka, Sakwats Mana, Sikataiyo, Sivuftotovi, Susöpa, Tocha, Tsil, Turposkwa, Wik'china.

Appendix B
Guide to the Symbolism of Kachina Features

COLORS:

Colors usually indicate direction. In Hopi culture there is no North or South. Directions to the Hopi evolve from the places of sunrise and sunset at the Summer and Winter Solstices. Stephen gives this chart:

Northwest	Yellow
Southwest	Blue and Green
Southeast	Red
Northeast	White
Above	Black
Below	All colors

Thus if you have a yellow bear Kachina doll it represents a Kachina who emerged from the Northwest, a green bear from the Southwest and so on. The red hair of a Malo Kachina indicates the sunrise. These directions are sacred. They indicate the directions from which the winds and rain come and the direction of the path of the sun.

ACCESSORIES:

Kachina dancers carry or wear appeals to the spirits. Evergreen boughs speak of vegetation and ever-renewing life, Tortoiseshell rattles give thanks to ponds and springs where turtles live, the feather is the messenger which carries the prayer to the dieties, the rattle calls the attention of the Kachinas while corn indicates the appeal for assistance with the forthcoming crops.

FEATHERS:

While federal laws do not permit use on a Kachina doll of authentic feathers, in the actual dance the participant adorns his mask with feathers of many birds—eagle, hawk, owl, parrot, flicker, crow and turkey are some. The feathers carry the personality of the bird—swiftness, bravery, keen sight and wisdom. Besides the symbolism of the specific kind of feather, further meaning may be attributed to the place of origin of the feather—i.e. breast, tail or wing. Also, how arranged on the dancer—standing alone, in pairs, fan-like on the head or grouped at the side or the rear.

MARKINGS:

Nothing is painted on the Kachina without meaning. Colton breaks the symbols down into six groups:

a. Animal and bird tracks.

b. Celestial symbols such as clouds, lightning, sun, moon and stars.

c. Vegetable symbols: Corn, flowers, cactus, etc.

d. A pair of vertical lines under the eyes represent the footprints of a warrior.

e. An inverted "V" over the mouth indicates certain Kachina officials.

f. Phallic symbols represent fertility.

Colton goes on to present a chart of symbols commonly used on Kachina masks:

(used with permission)

 ANIMAL TRACK

 BIRD TRACK

 CLOUD

 CLOUD

 LIGHTNING

 SUN

MOON

STAR

STAR

RAINBOW

RAINBOW

BEAN SPROUT

CORN

CORN

CORN

BLOSSOM

BLOSSOM

CACTUS BLOSSOM

WARRIOR MARK

MARK OF SOME OFFICE

REPRODUCTION

FRIENDSHIP

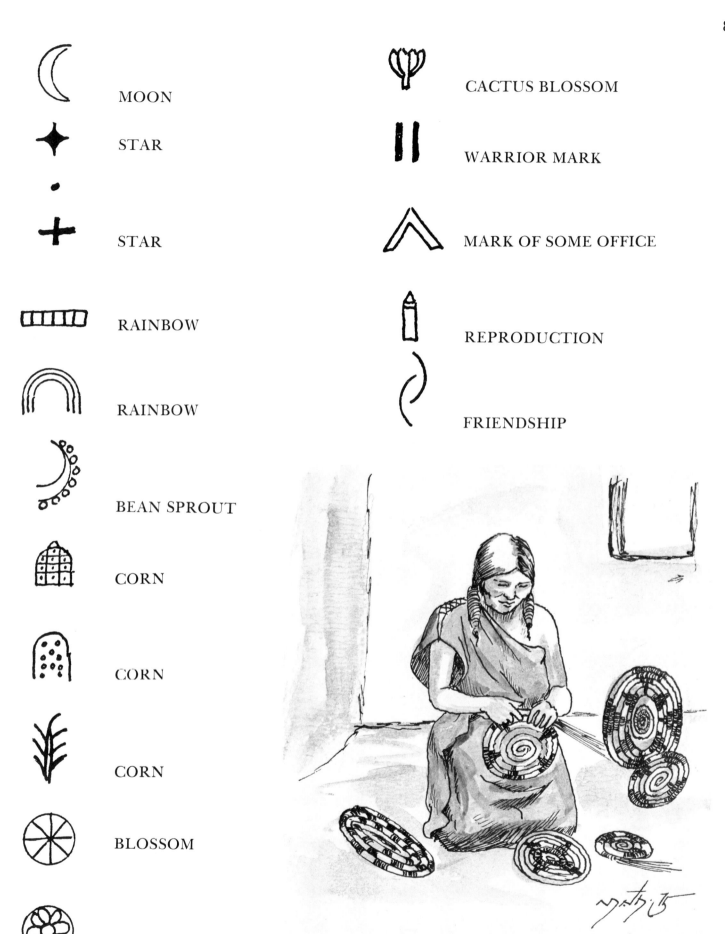

Hopi plaque weaver.

Appendix C
Living Hopi Kachina Doll Carvers

The following is a census of living Kachina doll carvers producing commercially on the Hopi Reservation as of January 1, 1989. Like all censuses it does not pretend to be complete. The list ranges from the occasional artist to prolific workers such as Elmer Adams, Leo Lacapa and Murray Harvey. The census was assembled with the cooperation of the Hopi Arts and Crafts Guild, Von Monongye and Bruce McGee. Signatures on dolls were used as a source in many cases and this may lead to deception as occasionally non-carvers will buy a doll, sign it and sell it.

Most occasional carvers reside on Second Mesa. In all Hopi there are probably no more than fifty "full time" craftsmen. Given a steady job, most carvers will stop carving. First Mesa turns out by far the most dolls. Little Bacapi houses the most top artists for its size—Jim Fred, Ronald Honyouti and Earl Yowytewa. Faraway Moencopi boasts Arthur Holmes, Dennis Tewa, Amos George and Wilfred Tewanima.

A few fine carvers such as Henry Shelton, Manfred Susunkewa and miniaturist Debbie Drye live more or less permanently off-reservation and thus are not listed. A number of carvers change residences frequently; some reside temporarily off-reservation.

There may be occasional spelling difficulties in dealing with the carvers names.

Adams, Deloria
 Elliot
 Elmer
 Martin
 Milford
 Robert
 Shirley
Ahownewa, Dale
 Dewayne
Albert, Gale
 Norman
 Ramon, Sr.
Ami, Aaron
 Delmar
 Edward
 Ferrell
 Francis
 Janis
 Preston
Andrews, Leander
 Leroy
Anton, Rowana
Aragon, Arles
Attakai, Henry Naha
Atukuku, Donald
Augah, Bruce
 Ross
Avachhoya, Arnold
 Merrill
Avayo, Arnold

Bahnimptewa, Steve
Balenguah, Bradley
Batala, Fernando
Beeson, Myron
Ben, Chester
Bilagody, Albert
 Mervin
Burton, Tony

Calnimptewa, Cecil
 Darrin
 Eugene
 George
 Mike
Carl, Arlin
 Milson
Chapella, Anderson
 Elidia
 Ernest
 Fred
 Larson
 Lee
 Mihpi
Chimerica, Forrest
 Ron
Choyou, Edwin
 Edwin, Jr.
Collateta, Robert
 Tom
 Tom, Jr.

Cordero, Johnathan
Cuch, Casey
 Norman

Dallas, Eugene
 Joseph
 Lawrence
 Leonard
 Oscar
 Reginald
 Virgil
Daniels, Floyd
Dashee, Teddy
David, John
 Kelly
 Kerry
 Larry
 Les
 Neil, Sr.
 Ryan Abbott
Dawahoya, Gene
Day, Jonathan
Dennis, Harlan
 Howard
Dewakuku, Alonzo
 Daniel
 Richard
Dowahoya, Beauford
Dukepoo, Gerald
Duwynie, Andrew

Andrew
Joe
Preston
Ronald
Wilfred

Fred, Aaron
 Henry
 Jim
 Julian
 Malcolm
 Perry
 VerlanFredericks, Aaron
 Jacob
 Joe
Fritz, Alfred
 Armand
 Phillip

Garcia, James
Gash, Joe
Gashweseoma, Hubert
 Loren
 Myron
George, Ross
 Sankey

Hahonhoya, Lambert
Hamana, Walter
Hamilton, Loren

Hanawa, Milton
 Jerry
Harris, Larson
 Melson
 Michael
 Robert
Harvey, Blendon
 Calton
 Carlon
 Carlyn
 David
 Delwyn
 Eileen
 Felix
 Felix, Jr.
 Irwin
 Murray
 Philmon
 Vina
Hastings, Elizabeth
Hayeh, Garald
 Gary
 Godfrey
Healing, Fletcher
 Julia
Holmes, Arthur
 Douglas
 Ernie
 Tom
Holquin, Sherald
Honahni, Dana
Honanie, Aaron
 Ernest
 Jimmy Gale
 Jimmy Gale, Jr.
Honie, Louie
 Norman
 Shirley
Honyaktewa, Brent
 Cleve
 Damon
 Jerry
 Rayfield
Honyestewa, Luther
 Ralph
Honyouti, Brian
 Clyde
 Harvey
 Loren
 Ronald
Honyumptewa, Newton
 Ronnie
Howard, Frankie
Howato, Lemuel
Howesa, Patrick
 Randy
Hoyungowa, Bobby
 Carlos
 Manuel
 Merrill
 Troy
Huma, Baldwin
 Damon

Edward
James
Marlin
Wilfred
Humeyestewa, Stanford

Jackson, Bennett
 Dale
 Esther
 Ivan
 Kayenta
 Marcus
 Marty
 Otille
 Roger
 Sanford
 Skipton
James, Alvin
 Alvin, Jr.
 Ricky
 William
Joseph, Harlan
Joshevama, Gary
 Patrick
 Scotty

Kagenvama, Bennett
Kaquoptewa, Carlos
 Robert
 Samuel
Kaursgowa, Jr., Milson
Kaye, Wilfred
 Wilmer
Kayquoptewa, Brandon
 Darwin
 Richard
Kewanwytewa, Bennett
 Duane
Kevama, Darrell
 Lawrence
 Loren
Kewanwytewa, Albin
 Darrell
Kewanyama, Elroy
Koiyaquaptewa, Boyce
 Michael
 Warner
Komalalaystewa, Augustine
 Edna
Komalestewa, Victor
 William
Koopee, Jacob
 Richard
Kootswatewa, John
 Wade
 William
Kooyahoema, Manuel
Kooyaquaptewa, Carlos
 Warren
Kopelva, Dewayne
 Donald
Koyiyumptewa, Steward
Kukuma, Dudley

Kuwanvama, Nelson
 Willis
Kyasyousie, Anthony

Lacapa, Addie
 Jerry
 Leo
Lalo, Leon
 Valjean
Lamson, Delmar
 Elman
 Ralph
Lanza, Patrick
 Randall
 Raymond
Leban, Ronnie
Leslie, Chapman
 Sammie
Lewis, Terrence
Loma, Bryan
 Herman
Lomahaptewa, Don
 Farron
 Jimmie
 Linton
Lomahquahu, Alfred
Lomatska, Kevin
 Leeford
 Riley
Lomakema, Lattrell
 Leon
 Seymour
Lomatewama, Austin
Lomauhie, Carlyle
Lomayaktewa, Clifton
 Clyde
 Donnie
 Edward
 Edwin
 Harold
 Marshall
 Moody
 Narron
 Ronald
 Roosevelt
 Stanley
 Starlie
 William
Lomayestewa, Lendrick
 Stetson

Makhee, Vern
Mansfield, Benjamin
 Vernon
Martin, John
 Lorenzo
Martinez, Frank
Masayestewa, Willard
Mase, Richard
Monongye, Bradley
 Leon
 Nelson
 Von

Willis
Mowa, Jr., Augustine
 Clifton
 David
 Tim
 Wilson
Mutz, Earl
Myron, Leon
 Paul

Naha, Albert
 Hank
 Neal
Nahee, Marcus
 Orme
Nahsomhoya, Bertram
 Joel
 Lambert
 Stacey
Namingha, Abel
 Frankie
 Sanford
 Waylon
Namoki, Dana
 Elwyn
 Hiram
 Lawrence
 Raleigh
 Tyson
 Virgil
 Watson
Nasavaema, Bernard
Naseyowma, Curtis
Nash, Kevin
 Troy
Nasoftie, Bennie
 Frazier
 George
 Hastings
 Nolan
Nasonhoya, Dewey
 Roy
Navasie, Alvan
 Geri
 Harriet
 Harrington
 Randall
Nequhtewa, Edward
 Ferrell
 Harold
 Henry
 Merrill
Nevaktewa, Edward
 Elmo
Nevyaktewa, Austin
 Delbert
 Norman
 Viness
Nicolas, Gary
 Stewart
Numkena, Arnold
 Bradford
 Gibson

Nathaniel
Rudy
Thomas
Nutumya, Floyd
Harry
Lonnie
Randall
Thomas

Omahoya, Marlinda
Oso, Jr., Arthur
Ovah, Gill
Grover

Pashano, Alton
Pavatea, Jonathan
Pela, Gordon
Lane
Maybelle
Roxy
Pentewa, Richard
Phillips, Bradford
David
Erwin
Loren
Myron
Rod
Pochoema, Garrett
Kevin
Pohleahla, Rudeford
Wayne
Pohuyouma, Raleigh
Polacca, Arlen
Calvin
Clinton
Harold, Jr.
Marvin
Poleahla, Adrian
Edward
John
Larry
Nick
Nina
Randall
Wendell
Polenoma, Tyler
Polestewa, Vincent
Poley, Jr., Oren
Poleyma, Jr., Walter
Polyumptewa, Morrison
Pongyesvia, Abbott
Clifford
Melbert
Poola, Eileen
Jasper, Jr.
Lemuel
Theodore
Poomaseva, Leroy
Poseyesva, Irwin
Poyauma, Darrell
Puhuyesva, Ted

Qochytewa, Bobby

James
Quanie, Kevin Horace
Lorenzo
Quinimptewa, Ken
Lester
Loren
Qumyimtewa, Willie
Quotskuyva, Robert
William

Rogers, Bennett
Roland, Gilbert
Roy, Coolidge
Roy, Coolidge, Jr.
David
Elva
Silas
Silas, Jr.
Velva

Sahmea, Dewey
Franklin
Philbert
Roy
Sahmie, Andrew
Finkel
Randall
Sahu, Harold
Raymond
Raymond
Sakenima, Laymond
Sakeva, Darrell
Satala, Elmer
Justin
Warner
Saufkie, Albert
Elmer
Paul, Jr.
Vaughn
Seehoma, Janie
Seeni, Benson
Sekayesva, Marvin
Sekayumptewa, Bradley
Leland
Selestewa, Andy
Innis
Ivan
Jackson
Leonard
Nathaniel
Orme
Virgil
Selina, Mike
Philbert
Roger
Vinton
Sequi, James
Leon
Melborn
Merrill
Sherald
Sewemaenewa, Bill
Paul

Willard
Woodrow
Shelton, Mary
Peter
Peter, Jr.
Shula, Nicolas
Shupla, Gary
Leonard, Sr.
Leonard, Jr.
Silas, Albert
Delbert
Dickson
George
Matthew
Michael
Sockyma, Bennett
Sulu, Carl
Ferron
Willard
Sumatzkuku, Andrew
Leroy
Ray

Taho, Emerson
Leonard
Takala, Daniel
Milton
Thomas
Talahaptewa, Herbert
Talahtewa, Cordell
Mike
Talas, Benson
Don
Henry, Jr.
Marian
Sheldon
Thayer
Talashoma, Darrin
Hershel
Lowell
Todd
Wilburt, Jr.
Talaswaima, Arlan
Eddie
Talawepi, Charles
Talawyma, Lloyd
Talyhaftewa, Elsie
Gibson
Stacey
Talyumptewa, Dale
Don
Ernie
Hendrickson
Henry
Tawahongva, Duane
Everett
Mark
Tawyesva, Irwin
Jim
Louise
Taylor, Alvin
Dennis
Eli

Hubert
Max
Milson
Tenakhongva, Darrell
Robert
Tewa, Ambrose
Dennis
Eric
Gary
Nobert
Wallace
Tewaguna, James
Tewanima, Fernnando
Ira
Milford
Wilfred
Toney, Dan
Tongovia, Tim
Willard
Toopkema, Debbie
Torivio, Conrad
Eddison
Emmett
Joseph
Willard
Torres, Keith
Tungovia, Carlos
Elton
Tim

Vincente, Emory
Martin

Wadsworth, Elson
Harlan
James
Ronald
Wytewa, Benjamin Jr.
Eloy
Ivan

Yaiva, Melvin
Merrill
Yava, Ronald
Yestewa, Carroll
Loretta
Paul, Jr.
Youvella, Alexander
Darren
Malcolm
Preston
Richard
Silas
Steve
Tino
Youyetewa, Frank
Yowytewa, Art
Earl
Frank
Merrill
Zena, Neal

Revised list of living Hopi Kachina Doll Carvers: Courtesy Bruce McGee and Von Monongye.

Glossary of Hopi Terms

Bahana White man
Driftwood Hopi English language term for cottonwood root from which dolls are carved
Hano Eastern third of First Mesa. Home of Tewa who emigrated from the Rio Grande about 1700
Kachin-Tihu Kachina doll
Kiva Underground chamber for religious activities. Sometimes a club-house
Mana Unmarried female of marriageable age
Moqui Early term for Hopi
Paho Cottonwood prayer stick thought to be the ancestor of the Kachina doll
Pahko Cottonwood root
Piki A very thin sheet-bread of the Hopis
Puchtiku Cradle doll
Tablita Highly decorated upright flat board fitted to head of female dancer
Taka Man
Tusayan Early Spanish name for Hopiland
Wuhti Married woman

Endnotes

[1] Wright, Barton. *Hopi Kachinas, the Complete Guide to Collecting Kachina Dolls.* Flagstaff, Northland Press, 1977, p. 6.

[2] Dockstader, Frederick J. *The Kachina and the White Man,* revised and enlarged edition, Albuquerque, University of New Mexico Press, 1985, pp. 26-27.

[3] Bourke, John C. *The Snake-Dance of the Moquis.* 1884. Reprint. Tucson, University of Arizona Press, 1984, p. 322.

[4] Schwartz, Don. *Kachinas as I See Them by Hopi Artist and Craftsman Coolidge Roy, Jr.* Louisville, Kentucky, Kachinas Ltd., 1983, p. 2.

[5] Haberland, Wolfgang. *Kachina-Figuren der Pueblo Indianer Nordamerikas aus Studiensammlung Horst Antes.* Karlsruhe, Badisches Landesmuseum, 1980?, pp. 5-19.

[6] Schwartz, *op cit,* p. 3.

[7] Dockstader, *op cit,* pp. 127-8.

[8] Spaulding, Robert Bruce. *Hopi Kachina Sculpture.* Master's Thesis, University of Denver, 1953, p. 3.

[9] Litman, Norma R. *The Acculturation of the Kachina Doll.* Master's Thesis, California State University, Long Beach, 1977, ch. VI.

[10] Dockstader, *op cit,* p. 123.

[11] Dockstader, *op cit,* p. 121.

[12] Bourke, *op cit,* p. 131.

Bibliography

Colton, Harold S. *Hopi Kachina Dolls with a Key to their Identification.* Revised edition. Albuquerque, University of New Mexico Press, 1959.

Dockstader, Frederick J. *The Kachina and the White Man.* Revised Ed. Albuquerque, University of New Mexico Press, 1985.

Earle, Edwin. *Hopi Kachinas.* New York, Museum of the American Indian, 1971.

Erickson, Jon T. *Kachinas, an Evolving Hopi Art Form?* Phoenix, Heard Museum, 1977.

Fewkes, Jesse Walter. *Hopi Kachinas Drawn by Native Artists.* Smithsonian Institution, Bureau of American Ethnology, Annual Report, 1903. (Reprinted in 1976 by McCrae Publications, Enumclaw, Washington.)

Haberland, Wolfgang. *Kachina-Figuren der Pueblo-Indianer Nordamerikas aus der Studiensammlung Horst Antes.* Karlsruhe, Badisches Landesmuseum, 1980? (In German)

Hartmann, Horst. *Kachina-Figuren der Hopi Indianer.* Berlin, Museum fur Volkerkunde, 1978. (In German)

Holien, Elaine Baran "Kachinas". *El Palacio.* 76 (Sept. 1970) 1-15.

Jacobs, Martina Magenau. *Kachina Ceremonies and Kachina Dolls.* Pittsburg, Carnegie Institute, 1980.

Litman, Norma Reva. "The Acculturation of the Kachina Doll" Master's Thesis, California State University at Long Beach, 1977.

Mills, George. *Kachinas and Saints; A Contrast in Style and Culture.* Colorado Springs, Colorado Fine Arts Center, Talor Museum, n.d.

Schwartz, Don. *Kachinas as I See Them by Hopi Artist and Craftsman Coolidge Roy, Jr.* Louisville, KY, Kachinas Ltd., 1983.

Spaulding, Robert Bruce. "Hopi Kachina Sculpture" Master's Thesis, University of Denver, 1953.

Stephen, Alexander MacGregor. "Hopi Journal" edited by Elsie Clews Parsons. Columbia University Contributions to Anthropology, 23, (1-2) Columbia University Press, New York, 1936, 2 vol.

Tanner, Clara Lee. *Southwest Indian Craft Arts.* Tucson, University of Arizona Press, 1968.

_____ *Ray Manley's Hopi Kachinas.* Tucson, Ray Manley Photography, Inc., 1980?

Washburn, Dorothy, Ed., *Hopi Kachina; Spirit of Life.* San Francisco, California Academy of Sciences, 1980.

Wright, Barton. "Kachina Carvings" *American Indian Art Magazine* (Spring, 1984) 38-45, 81.

_____ *Kachinas: The Barry Goldwater Collection at the Heard Museum.* Phoenix, W.A. Kruger Co., 1975.

_____ *Hopi Kachinas: The Complete Guide to Collecting Kachina Dolls.* Flagstaff, Northland Press, 1977.

_____ and Bahnimptewa, Clifford. *Kachinas: A Hopi Artist's Documentary.* Flagstaff, Northland Press, 1973.

Woman grinding corn into meal.

Index of Carvers Illustrated

Index of Kachina Dolls Illustrated

Potter.